IMAGES
of America

MURFREESBORO

IMAGES
of America

MURFREESBORO

Deborah Wagnon and Christian Hidalgo

ARCADIA
PUBLISHING

Published by Arcadia Publishing
Charleston SC, Chicago IL, Portsmouth NH, San Francisco CA

Printed in the United States of America

Library of Congress Catalog Card Number: 2007922158

For all general information contact Arcadia Publishing at:
Telephone 843-853-2070
Fax 843-853-0044
E-mail sales@arcadiapublishing.com
For customer service and orders:
Toll-Free 1-888-313-2665

Visit us on the Internet at www.arcadiapublishing.com

*In memory of one of Murfreesboro's great ladies, Evelyn Fite Anderson,
who in 1994 first knocked on this newcomer's door to teach me the
history of my home. –DW*

*Dedicated to all those who captured these wonderful images, collected,
preserved, and purchased them, and are continuing to pass them on to
future generations. –CH*

CONTENTS

Acknowledgments 6

Introduction 7

1. Town Square 9

2. Stones River and Civil War 25

3. History Loved and Lost 41

4. Blue-Ribbon Medicine 57

5. Academics and Aviation 73

6. Gatherings and Gathering Places 89

7. President's Lady, General's Wife 105

ACKNOWLEDGMENTS

The authors wish to acknowledge the generous and expert contributions of those who provided us both images and historical information along this journey across two centuries of Murfreesboro: Lisa Pruitt, director of MTSU Albert Gore Research Center; Jim Lewis, park ranger and historian at Stones River National Battlefield; Dennis Jungman, executive director of Oaklands Historic House Museum; Linda Duke, reference librarian at MTSU James E. Walker Library; the Tennessee State Library and Archives; the Rutherford County Archives; MainStreet; Shacklett's Photography (Southern Heritage Photography); Sarah King; Bill Jakes; Jim Laughlin; Whit Adamson; Gary Simpson; the Lively Family and the Southern School of Photography; the Leo Ferrell family; the H. O. Todd family; C. B. Arnett; Lillian Branson; the DeGeorge and Meshotto families; the Dement family; WGNS; the *Daily News Journal*; Ernest Johns; the Elrod family; the Mullins family; the Linebaugh Library; the Rutherford County Documentary; and Rutherford County Chamber of Commerce.

INTRODUCTION

If you pull back the bowstring, release the arrow and hit the bull's eye of Tennessee, you have found the city of Murfreesboro, located at the state's geographic center. Perhaps that central location is one of the reasons Murfreesboro was selected, for a time, as Tennessee's capital. Perhaps that is the reason there is a feeling of harmony of elements in the city and its surroundings. For those who live in Murfreesboro, that quality of balance and well-being in the community is generally understood to be true, albeit sometimes difficult to articulate.

Traveling from the city of Nashville toward Murfreesboro, a distance of approximately 30 miles, one notices the change in the horizon as one moves in the easterly direction. The sky becomes bigger, the horizon broader, and the light greater. This is a physical fact due to the terrain. The midsection of the state, called Middle Tennessee, is essentially a plateau surrounded by mountains, and Murfreesboro is the center spot of that high plateau. The soil is rich and the landscape a gentle rolling green.

What Murfreesboro has been over its almost 200-year history is a true home to its citizenry, some of those having later achieved worldwide acclaim, but most are known best to those within the community. It has been a center for politics, education, agriculture, aviation, medicine, music, and horse breeding. It has been a place of beautiful homes and celebrations as well as the bloody site of one of the most significant battles of the Civil War. Over time, some of the area's beautiful homes and buildings have been lost or destroyed. Once vibrant business enterprises have been overcome by the passage of time and by progress pushing the next generation of industry to the fore.

Murfreesboro has, however, one magical element that keeps the core of its being intact, and that is its town square. The square has been the heartbeat of the community since its inception, and against all the odds of urban sprawl in the 21st century, it still keeps that heart beating steadily. Positioned on the city's highest elevation, in the center of the square is the Rutherford County Courthouse. The courthouse, in its three incarnations, has been a magnet attracting people and businesses for the life of what was once a town of only a few square miles and is now at the center of the growing metropolis that is Middle Tennessee.

The late-18th-century surge of colonists to the region that became Rutherford County emanated from the settlement of Nashborough, later to become Nashville. Those colonists sought out the lush lands along a navigable stream called Stones River, named for Uriah Stone, who first explored that westward territory in 1766. By 1788, farms and gristmills along Stones River began the growth that would be organized as the county named for Revolutionary War soldier and explorer Gen. Griffin Rutherford.

On October 17, 1811, Murfreesboro became the county seat of Rutherford County. The town had first been called "Cannonsburgh" but was officially changed in 1811 by legislative amendment in the Tennessee General Assembly to "Murfreesborough" in honor of the Revolutionary War hero Col. Hardy Murfree. Colonel Murfree was a native of Murfreesboro, North Carolina. The North Carolina town had been named in honor of Murfree's father, that town's founder. Murfreesboro, North Carolina, was Colonel Murfree's birthplace and home to his early-1800s law practice, Murfree-Smith Law Office.

In 1823, Colonel Murfree's son William Hardy Murfree migrated to the new Tennessee town named in honor of his hero father, and thus the Murfree clan took domicile in their second namesake town, Murfreesborough, Tennessee. Over time that spelling was changed to its current spelling of Murfreesboro.

Tennessee's political history is rich and has proven the state of Tennessee to be fertile ground for many U.S. statesmen. One must marvel at the predominance this state—in particular, the Middle Tennessee section—has enjoyed on the national political stage over almost two centuries. What was it about the area that has bred or attracted so many leaders? Pres. James K. Polk, Pres. Andrew Jackson, and Davy Crocket all hail from Tennessee, with President Polk a product of Bradley Academy in Murfreesboro. Sam Houston was adjutant-general for the State of Tennessee and spent much time during those years in Murfreesboro. Additionally many admired women are from Murfreesboro, including First Lady Sarah Childress Polk; Jean Faircloth MacArthur; and the celebrated novelist Charles Egbert Craddock, the male nom de plume of Mary Noailles Murfree, granddaughter of Col. Hardy Murfree for whom Murfreesboro was named.

Murfreesboro has a quality that is best appreciated through its history. As author Mary B. Hughes wrote in 1942 in *Hearthstones: The Story of Historic Rutherford County Homes*, "(T)hese are some of the things . . . as told by the history books. But its real life, the life of the people, has centered in its homes, in the gracious, unhurried mode of living that we have come to associate with the South."

Murfreesboro is no longer that languishing culture but is a part of the extraordinary 21st-century growth of Middle Tennessee. The region, and Murfreesboro in particular, is as of this writing in the throes of tremendous economic development. In a perfect world, that evolution will be a winning one, and knowledge of what came before will hopefully continue the harmony of past and present.

Thus the images that follow are simply a few of the many faces and places that lit the path of Murfreesboro's two-century journey to the present.

One

TOWN SQUARE

Murfreesboro's famed novelist Charles Egbert Craddock once wrote the following passage: "(T)hen it became apparent . . . that God created first Tennessee, and with what was left over made the rest of the world."

Craddock's bias is heartily acknowledged, but that sentiment is shared and voiced by many a Tennessean. And that love for home is best evident in the emotion a town square evokes from locals and visitors alike. There is some indefinable quality about a town square that extends a hand and a sense of belonging. The best evidence of this is the disappointment and residual grief townships always seem to suffer when a town square dies or is diluted by the desertion of those leaving for the sprawling outer spokes of the geographic wheel.

Murfreesboro is a rare and wonderful example of a city with a thriving downtown square, as has been the case since its inception. The axis of the wheel is the grand courthouse, which was the first major structure built when Murfreesboro was named the county seat of Rutherford County. The courthouse's looming presence has been the primary catalyst for keeping the downtown alive, with great help along the way from extraordinary citizens who have fought hard to preserve its beauty and dignity.

The courthouse was once circled by farmers in their horse-drawn carriages on muddy unpaved roads, and it now stands tall, watching over the 21st-century automobiles circling for a parking spot en route to court, meetings, restaurants, or shops. The following 19th- and 20th-century images of Murfreesboro's businesses and people remind us of the significance of the square, in both its history and its future.

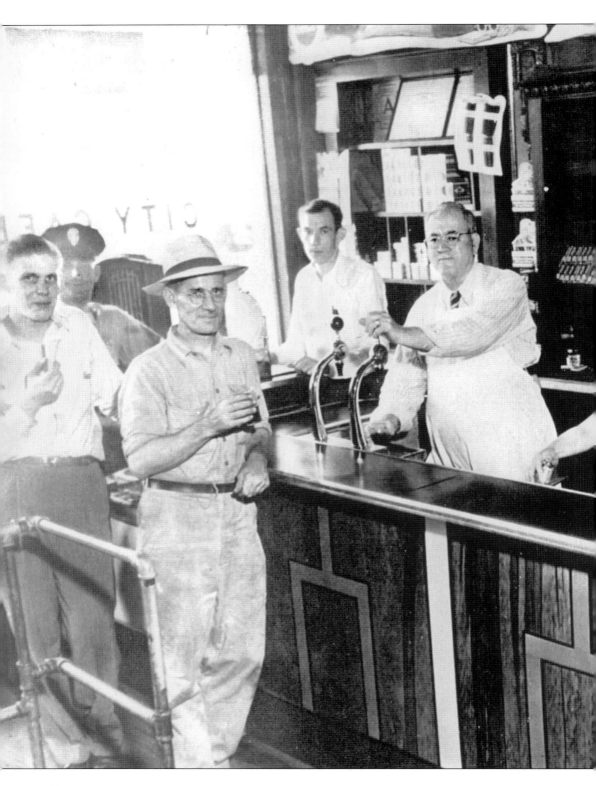

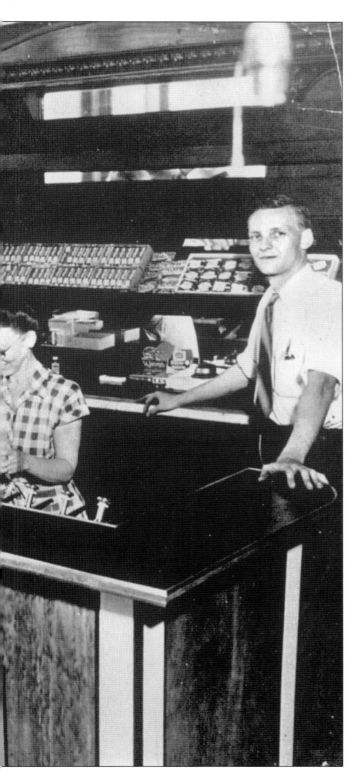

Brothers Dorsy and Henry Cantrell opened the City Café on the south side of the square on February 10, 1900. The café flourished and over a century later continues as a magnet for Murfreesboro locals, who exchange political and social news over plates of delicious Southern cooking. This photograph was taken in the 1940s at the soda fountain, which then existed at the front of the café. In 1952, and again in 1991, the café was moved just off the square to East Main Street, where City Café continues its familiar and loved traditions, including the legendary "City Café Straw Poll," taken among its customers prior to political elections. The results are released on the official day of early voting and have never to date been wrong in predicting the winner. (Courtesy of Shacklett's Photography.)

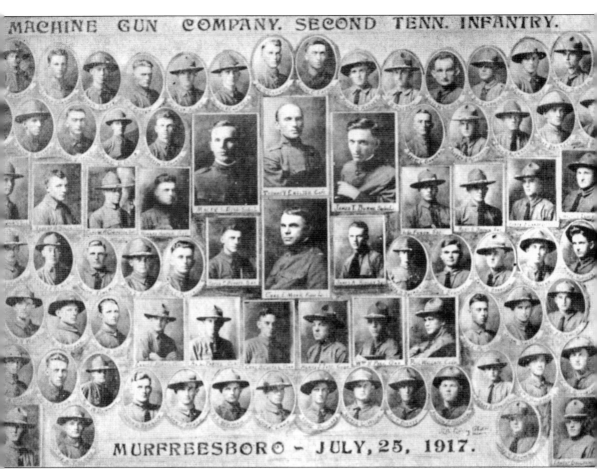

Serving one's country in a time of war is what citizens of Murfreesboro did when called upon. Pictured here are several dozen young men who fought during World War I. Names like Ridley, Sain, and Mason are carried on by their descendants. Most came home, but a few did not—their names can be seen on a stone memorial near the courthouse. (Courtesy of the Lee Lively family and the Southern School of Photography.)

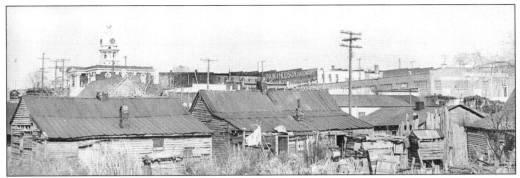

The slums of Murfreesboro were known as "Minkslide" or "The Bottoms." They were located in the flats along the banks of the Stones River on the site of present-day Cannonsburgh Village. This 1920s shot shows "The Bottoms" in grim contrast to the flourishing downtown perched up on the hill around the courthouse square. (Courtesy of Shacklett's Photography.)

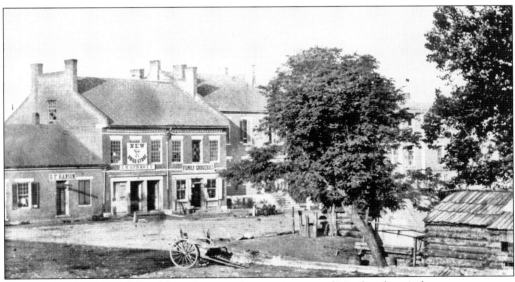

This is one of a series of the oldest photographs in existence of Murfreesboro's downtown square. A portion of the Union encampment can be seen on the right side of the photograph. The Union soldiers camped out year-round on the courthouse's lawn, which was sometimes frozen ground, using bricks from the Union-destroyed First Presbyterian Church to build their campsite fires. (Courtesy of the Albert Gore Research Center, Middle Tennessee State University.)

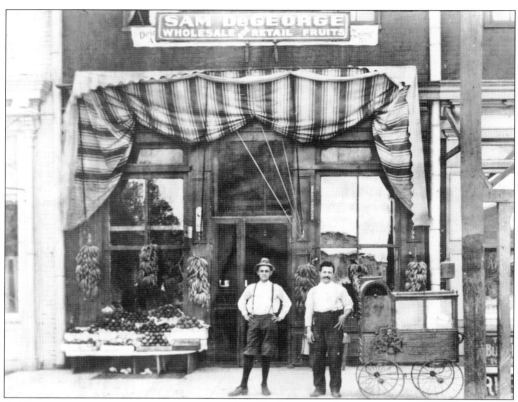

Sam DeGeorge (right) is seen with an unidentified man. Mr. DeGeorge was the Italian proprietor of a fresh fruit store, located on the east side of the square. Here they pose some time during the early 1900s in front of their large and well-stocked establishment. (Courtesy of the DeGeorge and Meshotto family.)

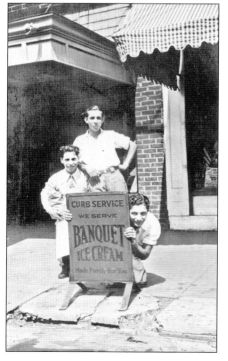

Seen here are Vance Meshotto, Vincent DeGeorge, and Tony DeGeorge in 1926, performing for the camera in front of the family's other enterprise on the square, the soda and ice cream shop. This marvel shop offered curb service. The servers would come out and take orders from customers socializing in or around their cars. (Courtesy of the DeGeorge and Meshotto families.)

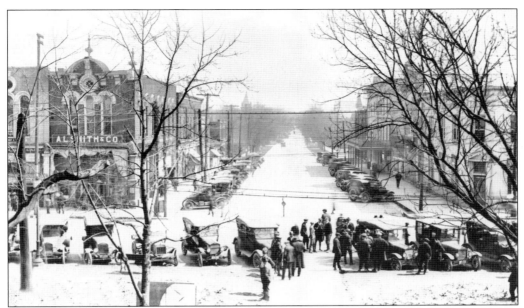

This beautiful 1923 shot of the square in the snow shows Murfreesboro men and their snow-covered automobiles. The old Jordon Hotel is visible right of center in the photograph. The A. L. Smith store, at left center, was in business on the square for many decades. (Courtesy of the Leo Ferrell family.)

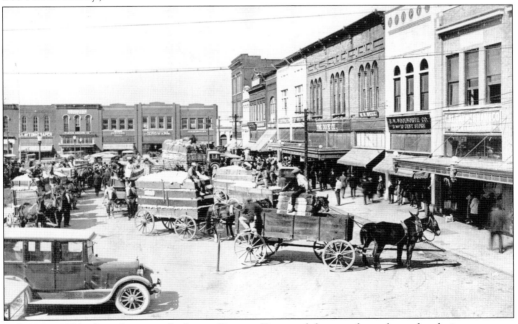

Taken in 1920, this photograph shows Cotton Day, and farmers have brought their cotton to market on the square. Cotton was one of the leading products cultivated by local farmers of that era. Two years later, the handbook of Murfreesboro and Rutherford County would report that the annual production of cotton was up to 12,000 bales. (Courtesy of the Rutherford County Documentary collection.)

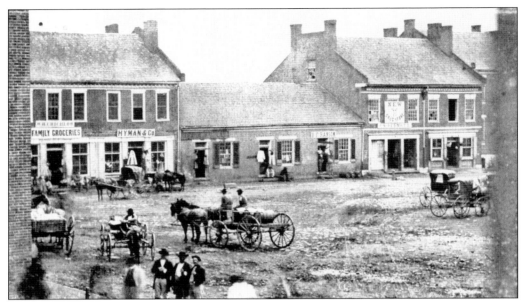

Another in the series of the oldest photographs in existence of Murfreesboro's downtown square, this image shows Crichlow General Store (left of center). The Crichlow name would grace many a facade in 19th- and 20th-century Murfreesboro, including the Crichlow Grammar School, named for James H. Crichlow. (Courtesy of the Albert Gore Research Center, Middle Tennessee State University.)

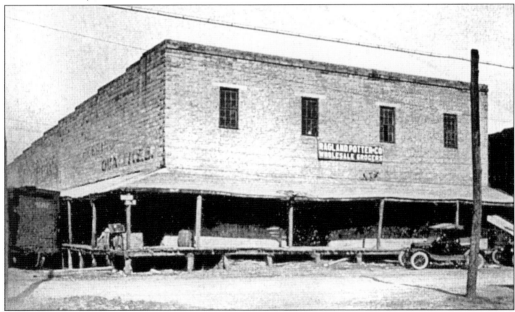

Pictured here is Ragland, Potter, and Company, a large wholesale grocer with multiple branches throughout Tennessee. This photograph was taken in the early 1900s. Another wholesale grocer at the time was Henry King and Company, formerly Overall, King, and Lytle when begun in 1900 as one of Tennessee's first small-town wholesale grocery companies. (Courtesy of the Leo Ferrell family.)

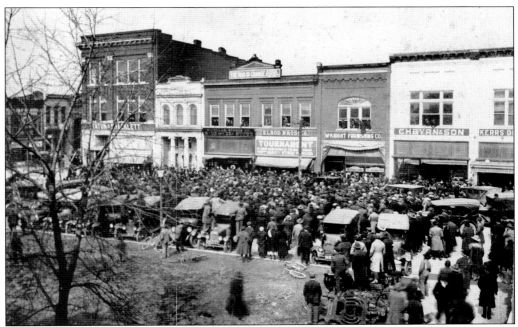

Seen here is yet another general store, the Elrods family-owned store, in the midst of a live turkey giveaway promotion. Legend has it that more customers showed up than anticipated, and many left disappointed. One can only imagine the bedlam of customers yelling and turkeys gobbling for their lives—their days (or perhaps hours) numbered. (Courtesy of the Elrod family.)

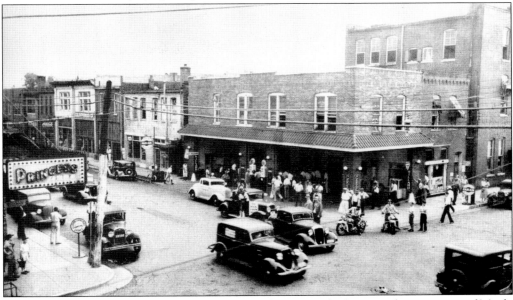

This 1934 photograph was taken by Lee Lively and captures the busy northwest corner of Maple Street and College Avenue just behind the square. On the left is the wonderful Princess Theater, the large movie theater once the regular destination of all movie lovers in Murfreesboro. At center in the photograph is Batey's Service Station. (Courtesy of the Lee Lively family and the Southern School of Photography.)

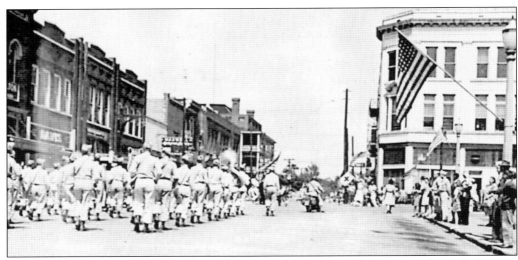

Here, in this early 1950s parade, soldiers from nearby Sewart Air Force Base, formerly Smyrna Airport, march away from the square, going northward on Maple Street. Note the Haynes Hotel in the background, which ultimately became the J. C. Penney and then modern-day Miller and Loughry. (Courtesy of Jim Laughlin.)

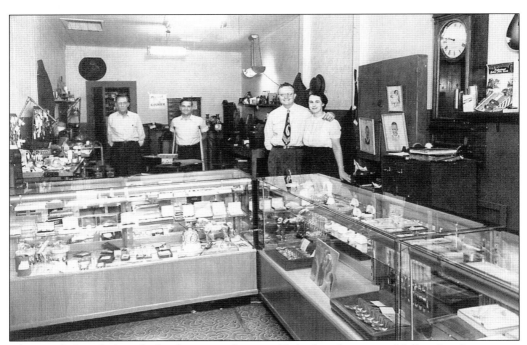

Along with City Café and other businesses long established on the square, Mullins Jewelry remains in business on the square after many decades. Pictured here are Herschel and Mildred Mullins in 1950 at the same location. The amazing Herschel Mullins is as of this writing still going to work on the square. (Courtesy of the Mullins family.)

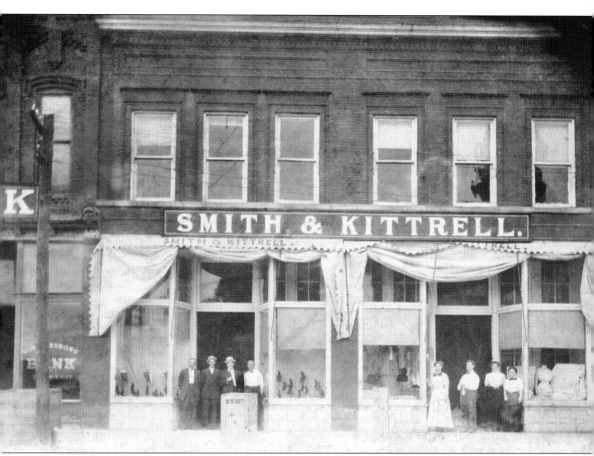

In this wonderful photograph of Smith & Kitrell on the square, shoes can be seen in the windows. The store had gentlemen's and ladies' areas on separate sides. To the left is the two-story Murfreesboro Bank and Trust Company. The bank's resources were touted in the early 1920s handbook of Murfreesboro and Rutherford County as "over $2,000,000." (Courtesy of Jim Laughlin.)

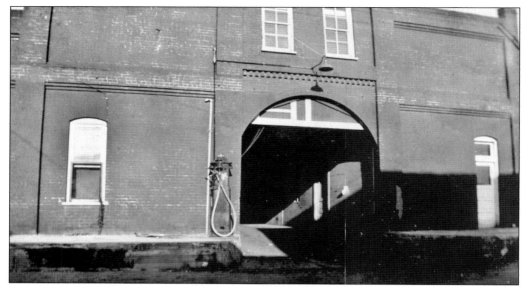

In this early 1900s photograph, the Murfreesboro firehouse can be seen on Maple Street on the west side of the square with its one arched doorway. Today the Murfreesboro Fire Department boasts six doors and dazzling red fire engines at its headquarters station located on the corner of Spring and Vine Streets. (Courtesy of Shacklett's Photography/ Southern Heritage Photography.)

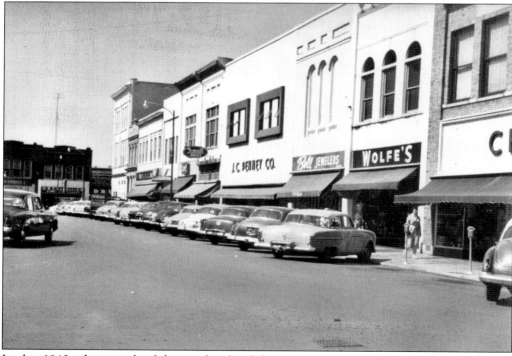

In this 1940s photograph of the north side of the square, parking meters had been installed. Haynes Hardware is visible to the left of the photograph and was located on the west side of the square. Bell Jewelers and Wolfe's also shared the north side of the square. (Courtesy of Shacklett's Photography/Southern Heritage Photography.)

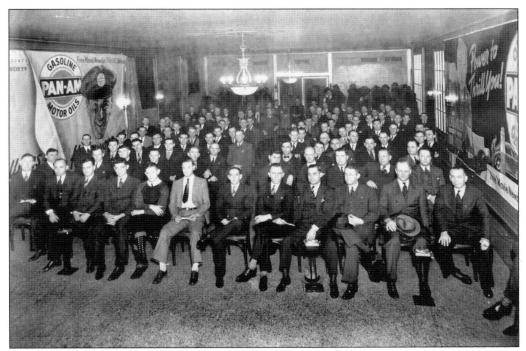

Here this serious, well-dressed audience of Murfreesboro men is viewing movie reels. Movietones and Hearst news reports were a major source of information during World War II. To the upper left above the large drawing of the Pan Am–capped attendant are the words "Free Movie News At All Pan Ams." (Courtesy of the Dement family.)

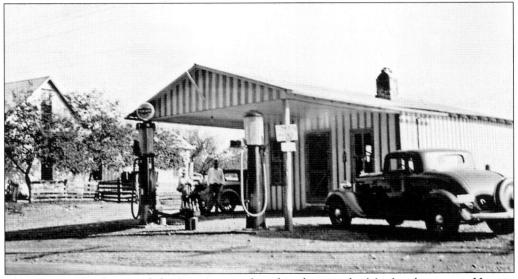

The Dement family owned the Pan Am gasoline franchise in the Murfreesboro area. Here in this post-Depression photograph, there are two pumps. The station offered leaded gas only, and full-service was the only service. The Pan Am globe atop the pump to the left reads, "Quality Gasoline." The Pan Am globe is valued at over $1,000 as a 21st-century collector's item. (Courtesy of the Dement family.)

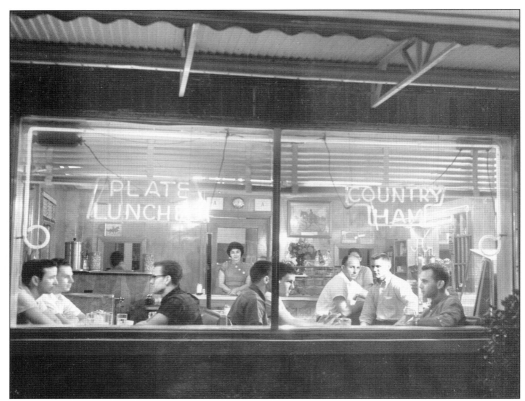

It is a quarter until noon, and the place is packed. Some things never change. City Café patrons are photographed at their booths from Main Street sidewalk looking into the restaurant window. This photograph was taken at the first of two East Main Street locations after the City Café moved from the south side of the square in 1952. (Courtesy of Shacklett's Photography/ Southern Heritage Photography.)

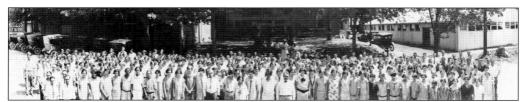

Lee Lively took this wonderful photograph of the large, predominantly female workforce at the Sunshine Hosiery Mill. The handbook of Murfreesboro and Rutherford County touted the Sunshine Hosiery Mill to potential newcomers to the area. Daily production was reportedly 12,000 pairs of hose, which were sold throughout the United States and Canada. (Courtesy of the Lee Lively family and the Southern School of Photography.)

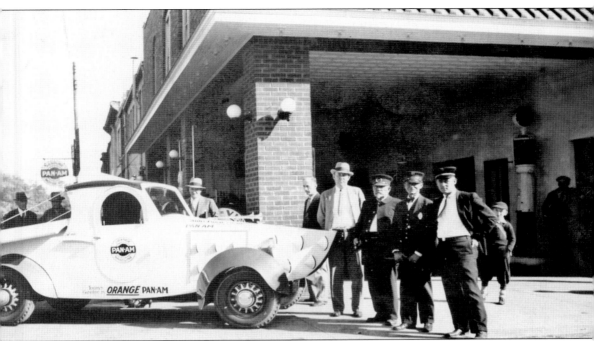

Mars came to Murfreesboro on one occasion, and it was miraculously captured on film. The "Batey's Mars Car" was a promotion for Pan Am gasoline. Notice the fellow dressed in Martian garb at center left in the crowd. Batey's was located on the north side of the square at Maple and College Streets, just across from the Princess Theater. (Courtesy of the Lee Lively family and the Southern School of Photography.)

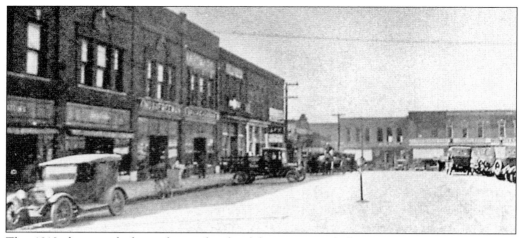

This 1910 photograph shows the south side of the square, and all forms of transportation are in evidence. A horse-drawn wagon is parked parallel to the curb on the right side, with the Model T pulled in to the curb on the left and the leaning bicycle left of center. Goldsteins department store is to the far left. (Courtesy of the Leo Ferrell family.)

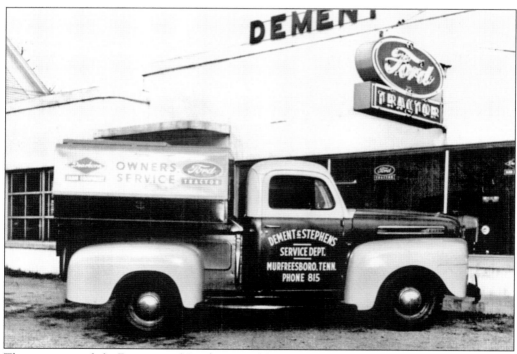

This service truck for Dement and Stephens Ford demonstrates the three-digit local Murfreesboro telephone number in use as late as the early 1960s. The population of Murfreesboro was 25 to 30 years away from the growth boom that would arrive in the early 1990s and transform its population count and terrain. (Courtesy of the Dement family.)

Two

Stones River and Civil War

The river named for Uriah Stone in the late 1700s is a timeline that runs from Murfreesboro's formation through its Civil War years and onward to its present-day incarnation as the fastest-growing region in Tennessee.

Stones River is in large part the reason for Murfreesboro's beginnings, due to settlers who veered out from Fort Nashborough along the river pathway. Fast-forward over two centuries, and Stones River is one of the greatest assets of the community's 21st-century lifestyle. The Murfreesboro Greenway is a long system of paved trails that run alongside the river. A journey along Stones River is a daily escape from urbanization for many because of the natural beauty in abundance along the banks of Stones River.

At the 1862 mark along that river timeline, however, the river's defining event is found. The Battle of Stones River—or the Battle of Murfreesborough, as it was also called—was a national event and dominated the front page of the January 6, 1863, issue of the *New York Times*. The horrific and bloody battle that began on New Year's Eve of 1862 and ended on January 2, 1863, occurred along the river within three miles from the courthouse and the main population of the city. The Union army's ultimate victory is said to have significantly affected the outcome of the Civil War, as it provided domination of the railroad. The line from Nashville through Murfreesboro and on to Chattanooga was the main artery for artillery and provisions, which, ultimately, led the conflict to the sea at Savannah.

The National Park Service has preserved and restored the national battlefield, and it attracts year-round visitors from around the world. The battlefield is beautiful terrain now thankfully forever protected. The thousands of simple white grave markers in its national cemetery are a sobering reminder of the many lives lost there.

April 10th. Singing Saturday. spent the evening over to Mrs
Monday Dunngoole. staid with Jennie Jordon Saturday night
Raining all day yesterday. still raining last Friday
night. The Yankees had good news. all the bells
in town were rung. & 36 Cannon fired.

April 13th
Thurs / Rained very hard all day Wdnesday did not
practice any. took a lesson. Joe is with us to
night. I heard this evening the bells were going
to be rung & cannons fired all day tomorrow

April 17th
Monday. Dispatch came yesterday. stating that Lincoln
was killed & also that Seward & son was badly
wounded. they are firing a cannon every half hour
this morning tolling Lincoln Death. good deal
of company here Saturday Friday helping us quilt Saturday
evening Sallie & Sallie Cox & I went up to see
Lizzie Miller.

April 19th
Wednes. President Lincoln funeral was preached today
at Soule Colledge. large attendance Citizen & Mil-
atary. Sallie & I staid with Joe last night. in the

On April 10, 1865, Emma Lane was 17 years old as she wrote in her diary from her family's Spring Street home in Murfreesboro: "April 10th Monday. . . . Last Friday night the Yankees had good news. All the bells in town were rung. & 36 Cannons fired." The Civil War had indeed ended on April 9, 1865, with General Lee's surrender to General Grant. Several days later Lane wrote: "April 17th Monday. . . . Dispatch came yesterday stating that Lincoln was killed & also that Seward & son was badly wounded. They are firing a cannon every half hour this morning tolling Lincoln Death." Abraham Lincoln had been assassinated three days prior, on the evening of April 14, 1865, at Ford's Theater in Washington, D.C. Lane went on to become the first lady of Murfreesboro as the wife of Mayor James H. Crichlow. (Courtesy of the Albert Gore Research Center, Middle Tennessee State University.)

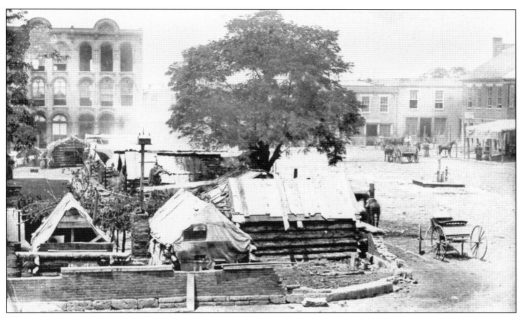

This photograph of Murfreesboro is one of the oldest in existence and captures the Union encampment on the grounds of the Rutherford County Courthouse. The presence of Union soldiers remained a constant in Murfreesboro for most of the Civil War, with the exception of the six months immediately preceding the Stones River Battle. (Courtesy of the Albert Gore Research Center, Middle Tennessee State University.)

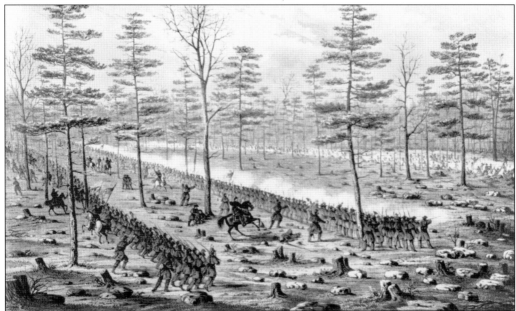

Artists' renderings of battle scenes were the primary method of translating the visuals of the war from the front. Here an A. E. Mathews sketch runs with the headline "The Battle Of Stone River or Murfreesboro" and illustrates Gen. Sam Beatty's brigade pushing forward through the frigid forest near Murfreesboro on December 31, 1862. (Courtesy of Stones River National Battlefield.)

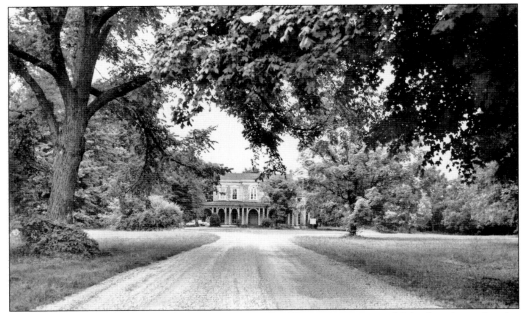

It was on Oaklands grounds that Nathan Bedford Forrest recaptured Murfreesboro for the Confederacy in July 1862. Later that year, Union general Rosecrans would defeat General Bragg at Stones River. The Maney family grounds at their Oaklands estate would then be taken over by Union encampments. (Courtesy of the Rutherford County Documentary collection.)

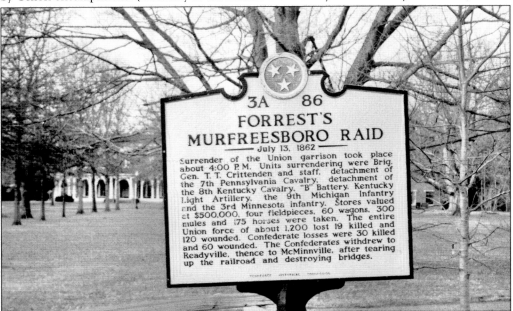

Nathan Bedford Forrest was born in Bedford County, Tennessee, in 1821. His successful July 13, 1862, raid on Union forces compelled the surrender of the Union garrison. Forrest's raid was the first defining event of the Civil War for the citizens of Murfreesboro. Forrest would be made brigadier general of the Confederacy one week later, on July 21, 1862. (Courtesy of Rutherford County Documentary collection.)

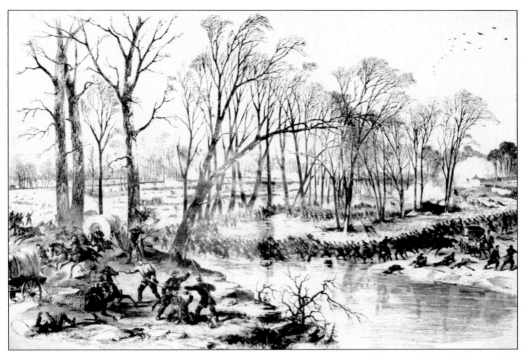

This A. E. Mathews sketch depicts the smoke from fierce "cannonading" and the fighting field of the Stones River Battle. Note Mathews's drawing to the lower right of soldiers removing their comrade from the battlefield on a stretcher. The blanket covering his face illustrates that he is one of the thousands who died in those three days of fighting. (Courtesy of Stones River National Battlefield.)

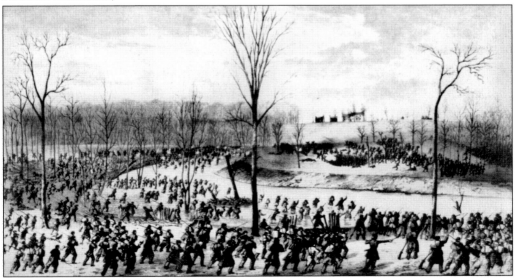

A. E. (Alfred Edward) Mathews (1831–1874) was prolific as a sketch artist of the Civil War. Seen here is his depiction of the charge of Union general Negley's division across the frigid waters of Stones River on Friday, January 2, 1863, the third and final day of the bloody battle. (Courtesy of Stones River National Battlefield.)

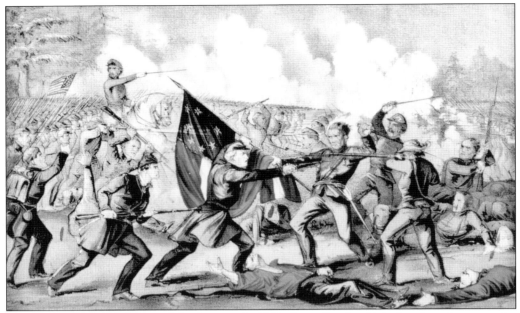

This is a rare color drawing of the January 2, 1863, Great Battle of Murfreesboro between the Union forces under General Rosecrans and the rebel army under General Bragg. The description reads as follows: "This may be one of the greatest battles of the war, commencing on the 31st December 1862 and after terrible losses, terminating on January 2, 1863 in a victory for the 'Stars and Stripes.' " (Courtesy of Stones River National Battlefield.)

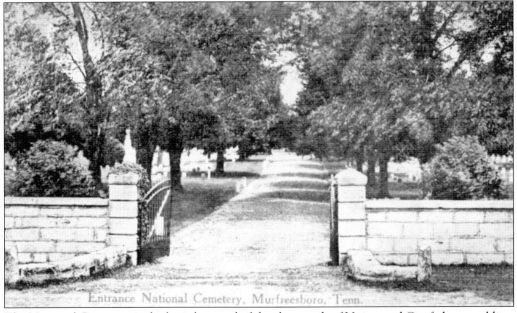

The National Cemetery is the burial ground of the thousands of Union and Confederate soldiers who lost their lives during the Stones River Battle. A mid-20th-century postcard depicts its gated entrance. On either side of the driveway, note the beginnings of the low, white grave markers that populate the grounds for as far as one can see. (Courtesy of Stones River National Battlefield.)

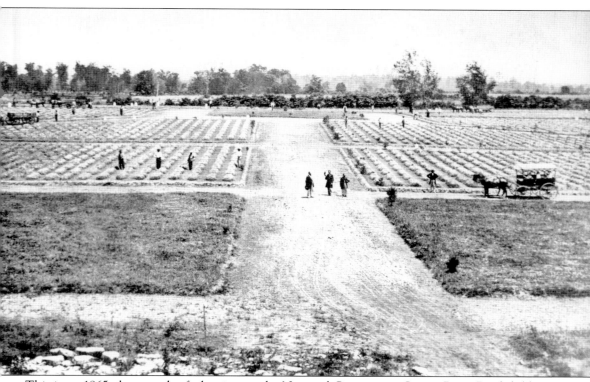

This is an 1865 photograph of what is now the National Cemetery at Stones River Battlefield. It appears that workers are tending the graves, which would have been an overwhelming task given the number of fallen soldiers. The Civil War would end that year, and the grave sites were Murfreesboro's primary reminder of the war's horror just two years prior. One of the National Battlefield Museum's archival treasures is a map drawn by Chaplain J. M. Whitehead on a page in his Bible. He drew the site of burials, noting nearby landmarks to identify the location of the graves. He wrote on the base of the map as follows: "Helped in the burial of our fallen boys on December 31, 1862. Buried 8 men 125 feet Southeast of the Surgeons tent along the edge of the woods. God Rest Their Souls." (Courtesy of Stones River National Battlefield.)

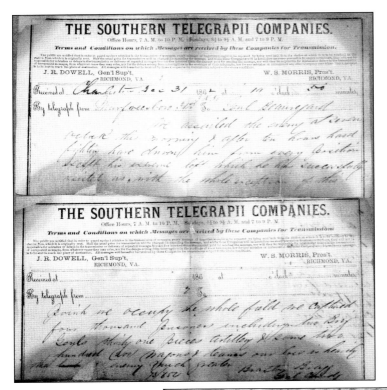

Confederate general Braxton Bragg sent a telegram to General Beauregard in Charleston at the end of the first day of fighting on December 31, 1862. It reads in part as follows: "We assailed the enemy at seven o'clock this morning and after ten hours hard fighting have driven him from every position except . . . our loss is heavy; that of the enemy much greater." (Courtesy of Stones River National Battlefield.)

The Saturday, January 2, 1863, issue of the *Charleston Mercury* prematurely reported a Confederate victory. Its far left column sets out verbatim the two telegrams received in Charleston by General Beauregard from General Bragg. In the second news column, under the title "The Victory at Murfreesboro," the *Mercury* reported, "General Bragg has sent us a most acceptable New Year's gift." (Courtesy of Stones River National Battlefield.)

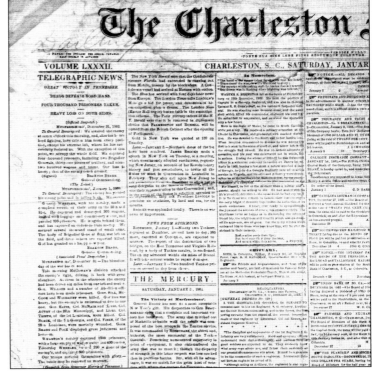

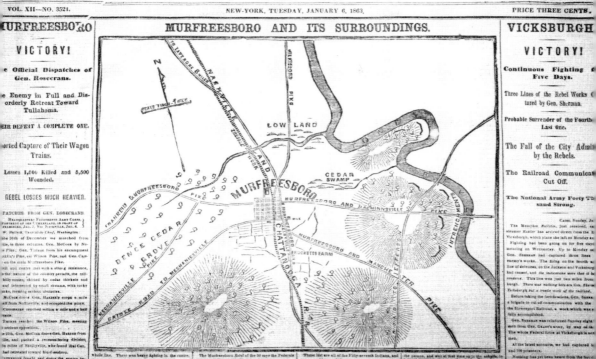

On January 6, 1863, Murfreesboro dominated the cover of the *New York Times*. The nation's leading Union newspaper would devote much of its front page to Murfreesboro and the Union victory at Stones River, including a map of the battleground. Note that the city of Murfreesboro is depicted in the pattern of block squares at the center of the map. The designated areas on the map include "dence cedar grove" and "cedar swamp." Headlined as "Murfreesboro Victory!" the column's subtitles included the following: "The Official Dispatches of Gen. Rosecrans," "Their Defeat a Complete One," "Our Losses 1000 Killed and 5500 wounded," and "The Rebel Losses Much Heavier." This news report was issued after the final conclusion of the battle, unlike that of the *Charleston Mercury*, which made a preliminary and ultimately inaccurate report of the final results of Stones River Battle. (Courtesy of Stones River National Battlefield.)

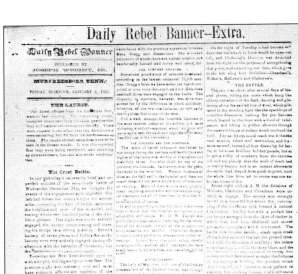

The *Daily Rebel Banner* was the Confederate newspaper published by Joseph Wright Jr. The *Rebel* was generally the first written news available to the people of Murfreesboro with regard to the battle occurring so near to them at Stones River. This Friday morning January 2, 1863, "Extra" edition states that "(i)t was also reported that they were being reinforced." That would turn out to be true. (Courtesy of Stones River National Battlefield.)

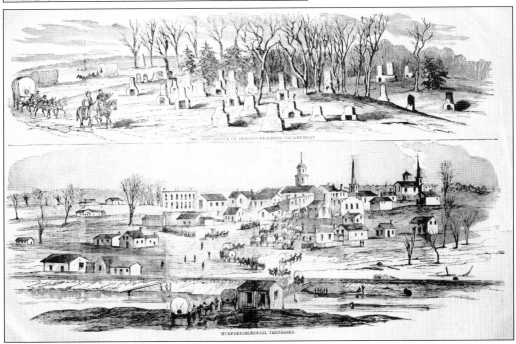

Harper's Weekly, one of the oldest publications in the history of the United States, published this sketch of the Battle of Stones River. The top one is titled "The Appearance of Bragg's Deserted Encampment." Note that here, as opposed to in other news articles, the city is spelled out in full as Murfreesborough. The abbreviated form favored by most newspapers had then evolved into "Murfreesboro." (Courtesy of Stones River National Battlefield.)

The U.S. Department of the Interior acquired the battlefield grounds and cemetery and created a protected reserve under the aegis of the National Parks Service. Park rangers are both overseers of the battlefield acreage as well as experts with regard to the history of the battle in particular and the Civil War in general. Here a park ranger speaks with visitors to the battlefield. (Courtesy of Stones River National Battlefield.)

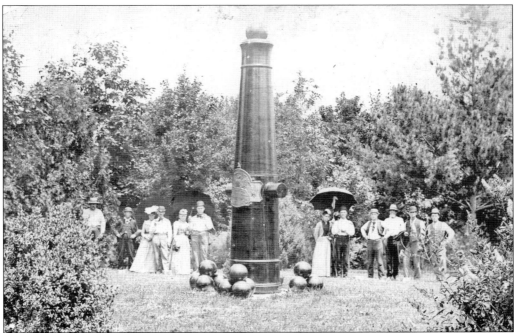

Here is a reunion photograph taken on a warm sunny day at the National Battlefield at Stones River. It appears to have been taken in the late 1800s or early 1900s. Note the stacked cannonballs at the base of the monument. (Courtesy of Stones River National Battlefield.)

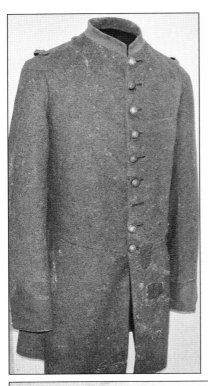

This coat hangs in a glass case inside of the Stones River National Battlefield Museum. It belonged to the fallen soldier Henry Hall, who is the subject of the letter below. Hall's family members were fortunate in having knowledge of the specifics of their loved one's death, which most next of kin did not have. (Courtesy of Stones River National Battlefield.)

This is a death letter written from a camp near Manchester, Tennessee, following the Battle of Stones River. Regarding Henry Hall, it reads in part as follows: "Dear Mrs. Hall . . . feeling it a duty to give you information in regard to Henry who you have doubtless been informed met his fate on the field of Murfreesboro. He was killed almost instantly by a cannonball . . . Severing his legs from his body on Friday the 2nd of January." (Courtesy of Stones River National Battlefield.)

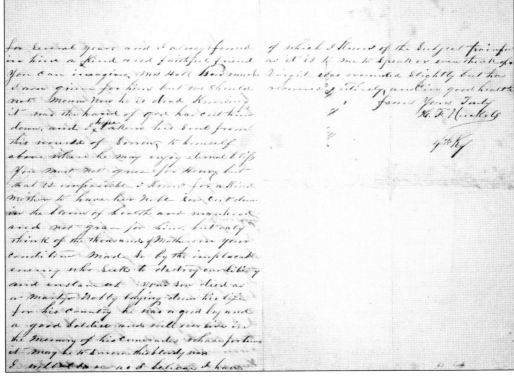

Pay Department U. S. A.

Cincinnati, O. Jany 9 1863.

Mrs. J. E. Cummins,
 Sidney, Ohio.

I write you at the request of Col. Swayne of the 99th Ohio, with whom I came up on the Boat from Louisville. He would have written you himself, but was wounded by a piece of a shell at the battle of Murfreesboro in the right arm & cannot write. He wishes me to say to you that Lt. Col. Cummins passed through the late battles entirely Safe & unharmed, The report of his being wounded is a mistake
 With Respect
 J. A. Bope, 99th Ohio =

This note from the war department, dated January 9, 1863, to Mrs. J. E. Cummins of Sidney, Ohio, informed her that Lt. Col. Cummins was indeed alive and "would have written you himself but was wounded by a piece of a shell at the battle of Murfreesboro in the right arm and cannot write." (Courtesy of Stones River National Battlefield.)

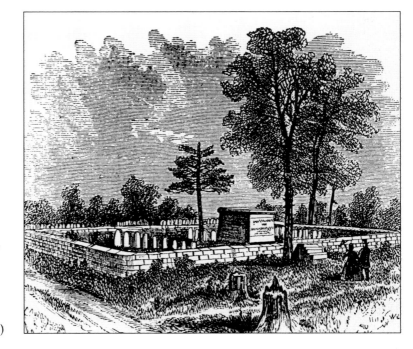

This is a pen-and-ink drawing of the Hazen Monument, which stands in the National Battlefield. This drawing is among the archives in the battlefield museum. (Courtesy of Stones River National Battlefield.)

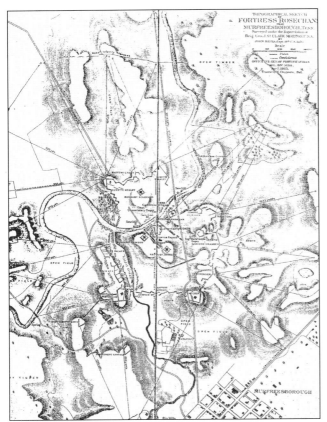

This map is that of General Rosecrans, the commanding general of the Union forces at the Stones River Battle. Fort Rosecrans, built by the Union soldiers, is memorialized today as a major trailhead along the Greenway system adjacent to Stones River. (Courtesy of Stones River National Battlefield.)

Union soldiers in the Michigan 21st pose for this amazing photograph. The presence of young boys as soldiers is startling. To the upper right, seated and standing, at least three boys appear to be unimaginably young to be fighting. While most were drummers for the company, many young boys died on the battlefield. (Courtesy of Stones River National Battlefield.)

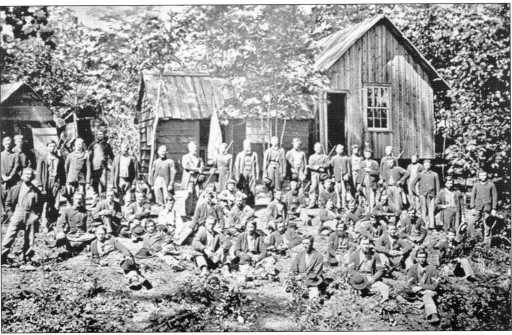

This post–Civil War monument to the Confederacy still stands on the courthouse square of Murfreesboro. Beginning in 1863 immediately after the horrors of the Stones River Battle, the town was occupied by the Union army for most of the Civil War. This monument was constructed in honor of those who served and died fighting on behalf of the Confederate army. (Courtesy of the Rutherford County Documentary collection/Cline.)

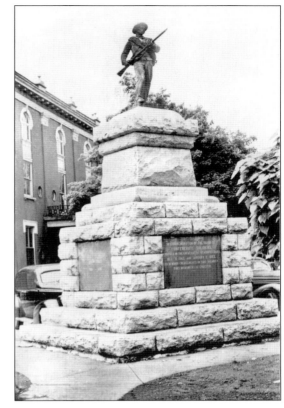

Joseph R. Prentice of Kansas fought in the Battle of Stones River at Murfreesboro and was in 1894 awarded the Medal of Honor for "gallantry in action." A young private during the battle, Prentice wore the medal proudly in the later years of his life. (Courtesy of Stones River National Battlefield.)

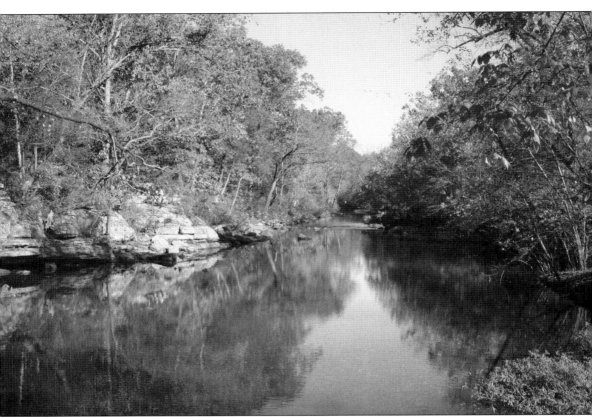

The Stones River is much more that the Stones River Battle that brought it such notoriety during the Civil War. The river was the catalyst to the migration to the Southeast from Nashville that became the city of Murfreesboro. The river has in the past decade or so witnessed a new mass migration into the region. The river itself has been protected and remains a respite from urbanization. The Greenway system is arguably the crowning jewel of the community and the Stones River, as is the battlefield, which remains protected by the National Park Service. The Greenway system continues to grow and expand in multiple directions, creating an extraordinary natural pathway throughout Rutherford County. The asset of this river continues to impact Murfreesboro, as it has from the very beginning. (Courtesy of Stones River National Battlefield.)

Three

HISTORY LOVED
AND LOST

Murfreesboro's writer Andrew Lytle wrote in his 1960 foreword to the reissued 1942 *Hearthstones*: "(I)f the young look at these houses of an older day, when life was tougher and freer, more mannerly, when at least the child knew his name, that there is something in a name . . . if the young look at these houses, it might have some effect upon them, in the sense of knowing that there is such a thing as tradition and continuity. It might. More mysterious things have happened."

And so we go on and we try.

The now infamous Hiram Jenkins house was present in the thick of the action during the bloody Battle of Stones River. Built in the 1850s, it stood on land held by the Jenkins family since 1797. The Jenkinses watched much of the Civil War battle in horror from their second-floor portico, deafened by cannons shot by Union forces just steps away. In June 2006, this property listed on the National Trust for Historic Preservation was razed. That permanent loss has reignited the flame for the organized preservation of all of Murfreesboro's remaining pieces of history.

The Princess Theater once stood on the busy northwest corner of the square at College and Maple Streets. In this 21st-century world of the cineplex, one can only imagine sitting in that grand theater hall anxiously awaiting Hollywood's latest release on the big screen.

Murfreesboro is fortunate in its abundance of historic structures and in its community of preservationists that continues to grow. The images that follow reflect the places and the people of Murfreesboro in times past.

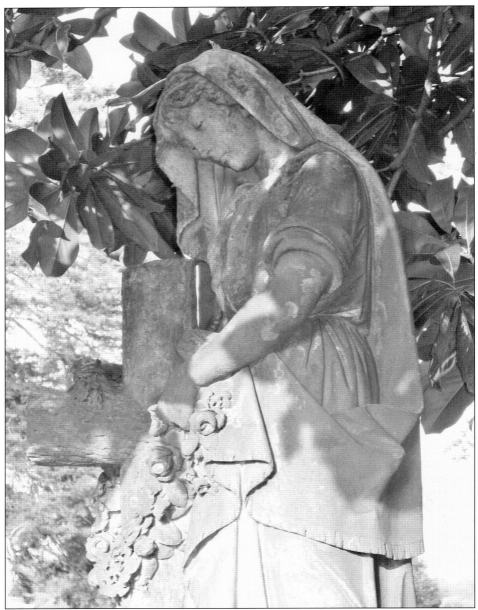

This statue in Evergreen Cemetery reflects the all-too-common early deaths of children in 19th-century Murfreesboro. Nama (16 years) is pictured here, and her first cousin Martha, who died at 14, lies steps away in the family burial ground. The girls were members of the Collier family, which over seven decades produced several mayors of Murfreesboro, as well as civic leaders including the director of the NC & St. Louis Railroad and the president of the board of education. The girls were each born in 1870 and died in the family compound at 500 North Spring Street, later christened the Collier Lane Crichlow House by the National Trust for Historic Preservation. Evergreen Cemetery was originally within the Maney family landholdings at Oaklands and was created as a result of the Maney family's sale of portions of their land because of post–Civil War financial difficulties. (Courtesy of Wagnon Collection.)

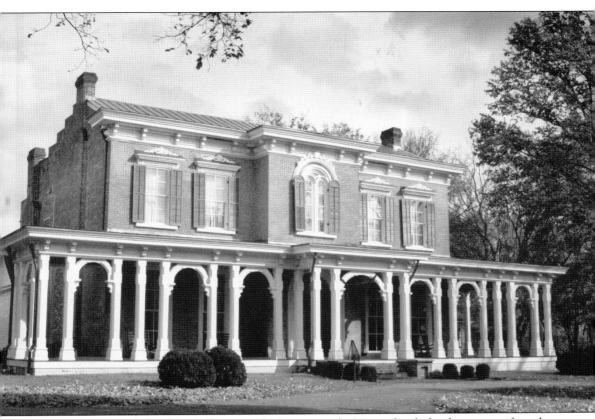

What was once called Oaklands Plantation by its owners, the Maney family, has been magnificently restored since the mid-20th century. The house was poised for demolition in 1959, when a group of women came to its rescue and formed the Oaklands Association. It is Murfreesboro's premier tribute to historic preservation. Oaklands Historic House Museum, as it is officially known in the 21st century, is a thriving destination for those seeking stories of the plantation's past. An extraordinary element of Oaklands is its availability to the community. Private parties abound in its adjacent facilities, and in 2007, there have been great strides toward broadening its community access with a pavilion and play equipment for children. Maney Springs, the natural springs that were of such import to the Union soldiers during the Civil War, is now the centerpiece of the plantation's wetlands preserve. (Courtesy of Bill Jakes.)

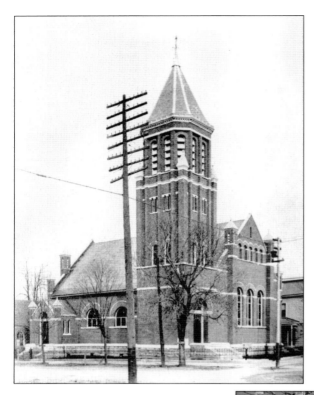

Pictured here is the First United Methodist Church. Originally erected in 1857, it underwent structural changes again in 1886. The church was located at the corner of College and Church Streets. The steeple tower was barely damaged in the 1913 tornado. The structure is now operating as a bank. (Courtesy of Jim Laughlin.)

This 1940 image is of the Murfreesboro Savings and Loan. Note the art deco style of lettering that had become architecturally popular by this time. The Savings and Loan was located on or near Maple Street, just north of the square. (Courtesy of the H. O. Todd family.)

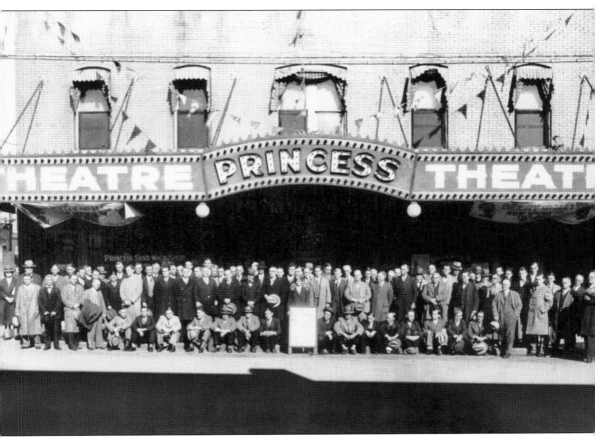

The wonderful Princess Theater was located at the busy northeast corner of the intersection of College and Maple Streets. Located diagonally across the street from the Princess was the popular Batey's service station. Congregated in front of the Princess on this occasion was the men's Bible study group from the United Methodist Church, located a block away at College and Church Streets. The study group elected to meet at the Princess, as it offered the most available meeting space in Murfreesboro. Note the center placard reading, "Bible Class." The Princess Sandwich Shop is visible to the left rear of the photograph. (Courtesy of the H. O. Todd family.)

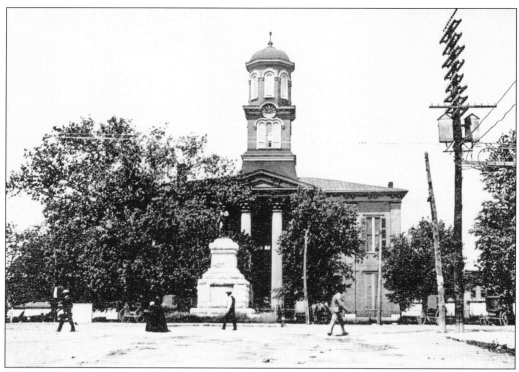

This pre-1907 photograph shows the Italianate cupola the courthouse had at the time. Since the early 1800s, the courthouse has burned to the ground twice and suffered through a tornado. It sits on the highest elevation of downtown, and its giant clock, which has always been the heartbeat of Murfreesboro, strikes the hour every hour of every day. (Courtesy of Bill Jakes.)

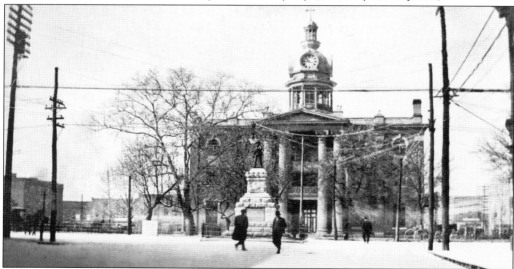

This 1910 photograph bears the cupola design as it exists today. The courthouse that stands now, in the 21st century, is the third incarnation. It has been perfectly restored, thanks to the expert guidance of Murfreesboro's historians. The original clockworks were discovered, restored about 2005, and are now on display at the Discovery Center after many decades lost. (Courtesy of Bill Jakes.)

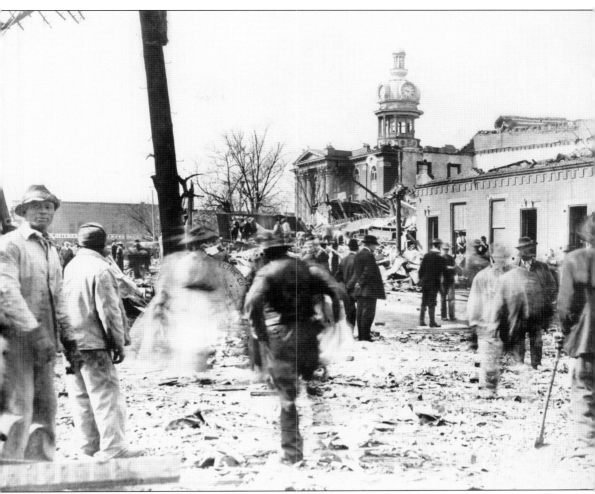

Seen here is the horrific damage to the square as a result of the powerful tornado that swooped through Murfreesboro in 1913. The tornado ravaged downtown and damaged or destroyed many buildings on the square. When all was said and done, 7 residents in the region had been killed and 15 injured. Men stand about the square all dressed up in their suits, vests, and hats. Note their faces as they sadly survey the damage of this killer twister. There is hardly a woman or child in sight in this photograph, likely taken the morning after. Some men can be seen crawling over the sharp metal and wood debris piled high on what was formerly the courthouse lawn. Goldstein and Sons department store is visible on the other side of the square. The landmark Goldstein's signage touting "Ladies Wear" and "Mens Wear" appears remarkably intact. (Courtesy of the Rutherford County Documentary collection.)

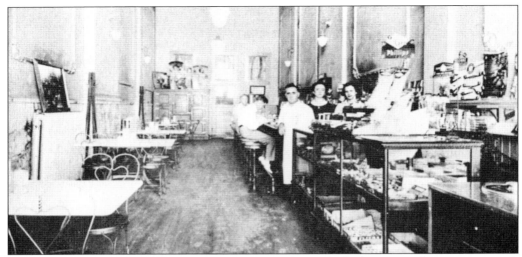

Dominic Miciotto owned the popular Busy Bee Café. Here he looks on as café customers perch on the counter stools. The Busy Bee was located at 119 Maple Street. Note the multitude of gentlemen's pipes to the right in back of the glass candy case. (Courtesy of Bill Jakes.)

This is one of the oldest known photographs of Murfreesboro. It was taken from the top of the courthouse at the center of the square. The date of the photograph is estimated at some time between the mid-1840s and 1860. The camera was invented in the mid-1840s. (Courtesy of the Albert Gore Research Center, Middle Tennessee State University.)

The Dixie Highway ran through Murfreesboro northwest of the square. This 1935 photograph is taken from the perspective of Maney Avenue, looking at the crossroads of the Dixie Highway. Maney Avenue is what was once the long drive up to the grand house at Oaklands Plantation. Dixie Highway was reported in the 1920s and 1930s to be one of the better-constructed roads in the South. (Courtesy of Bill Jakes.)

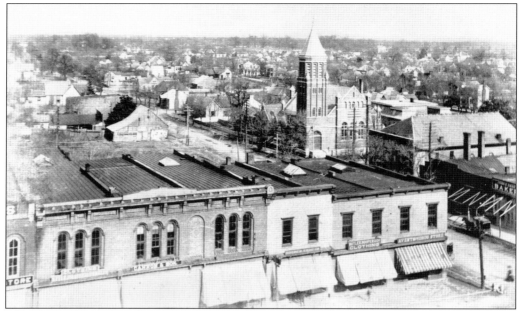

The photograph was taken from the courthouse clock tower in a northerly direction. The Methodist church can be seen at center right. The two-story Collier Lane Crichlow house, built in 1850 on Spring Street, is also visible to the northeast. It was home to several mayors during the era of this photograph. (Courtesy of the Albert Gore Research Center, Middle Tennessee State University.)

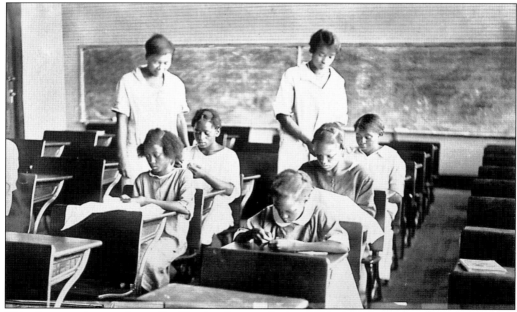

This photograph was taken at Bradley Academy in the late 1920s. The young female students seated at their desks are learning to sew, with their instructor watching over them. Bradley Academy was at this time the primary educational institution for the African American community in Murfreesboro. (Courtesy of Shacklett's Photography/ Southern Heritage Photography.)

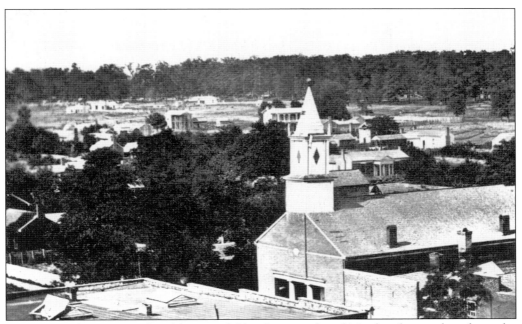

This is another among the oldest available photographs of Murfreesboro taken from the courthouse tower on the square. The tower still provides a favorite photographer's perch for images of 21st-century Murfreesboro. (Courtesy of the Albert Gore Research Center, Middle Tennessee State University.)

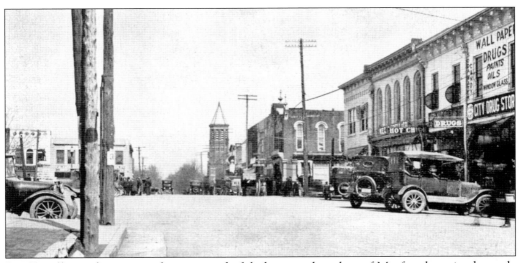

Leo Ferrell was the source of many wonderful photographs taken of Murfreesboro in the early 20th century. This 1910 photograph was originally taken for printing onto a postcard. The view is of College Street on the east side of the square. Notice the ghosted image of a man walking in the right foreground. The eating establishments offered "chile" and "soda water." (Courtesy of the Leo Ferrell family.)

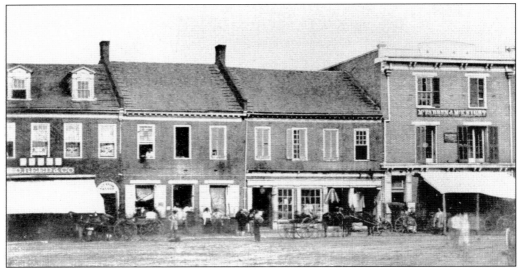

Another of the oldest shots of the Murfreesboro's town square is this image of shops and offices. The dirt road around the square is busy with horse-drawn carriages. Notice the ice cream saloon above the rounded-door entrance to the lower left of the photograph. (Courtesy of the Albert Gore Research Center, Middle Tennessee State University.)

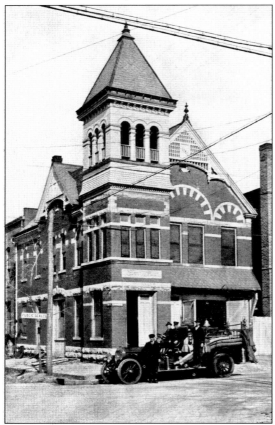

This city hall has little in common with the modern municipal complex of the present. Here the city hall marker was carved into stone and hung above the door. To the back right of the photograph, one can see men in a fire truck that has pulled out of the garage. The city hall was located on Vine and Church Streets, just off of the square. (Courtesy of the Leo Ferrell family.)

This photograph depicts the west side of the square in the early 1900s. These series of Cline photographs can be found at the Linebaugh Library and depict a robust turn-of-the-century city. There is no doubt the town square was the center of both social and commerce activities. (Courtesy of the Rutherford County Documentary collection/Cline.)

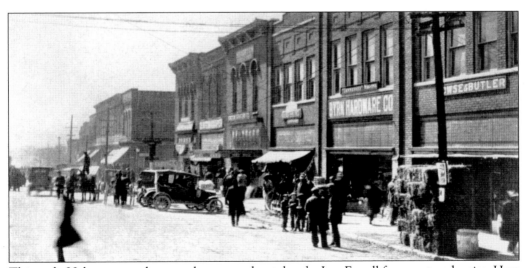

This early-20th-century photograph was another taken by Leo Ferrell for a postcard series. Here the west side of the square is seen at some time between 1900 and 1907. (Courtesy of the Leo Ferrell family.)

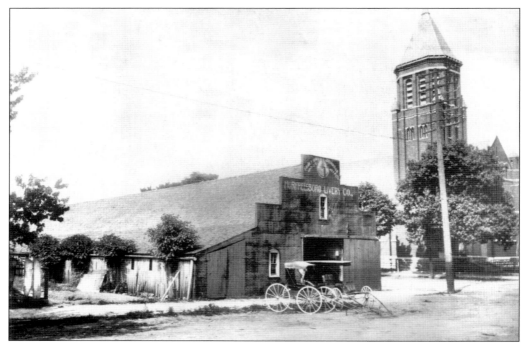

The livery stable of the 1800s was located at the corner of College and Church Streets. It later served as the site for the post office, then the library, and ultimately as the present center for the arts. Reportedly a Confederate officer shouted orders to his troops from atop the livery stable during Forrest's push to retake Murfreesboro during the July 13, 1862, raid. (Courtesy of the Rutherford County Documentary collection.)

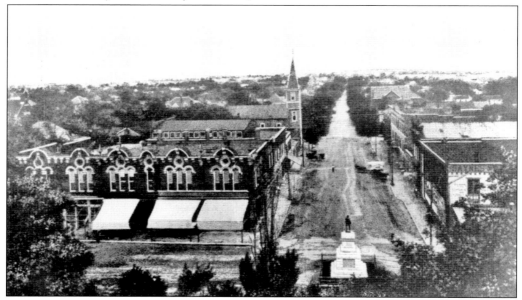

Note the W. B. Crichlow signage over the "Family Groceries" sign to the far left of the photograph. This is another of the early-1900s photographs taken yet again from the photographer's favorite perch atop the courthouse. (Courtesy of Bill Jakes.)

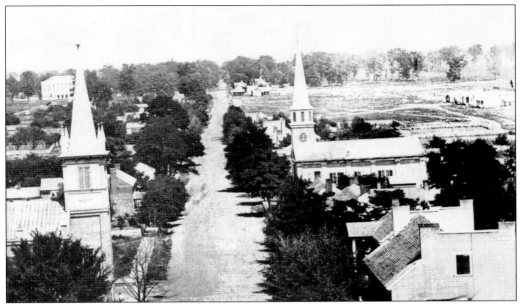

This image from the mid-1800s shows Main Street looking in an easterly direction toward the location of where the MTSU campus is today. Looking off to the left horizon, a large structure can be seen in the distance. That structure is likely Union University, a principal institution of the Baptist denomination that opened on May 2, 1841. (Courtesy of the Albert Gore Research Center, Middle Tennessee State University.)

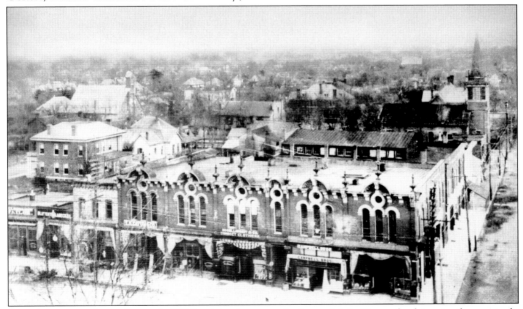

Another image from the early 1900s, this photograph shows Main Street looking in the westerly direction. Over the next century, most of the educational institutions would be constructed off of East Main Street, and the west—as shown in this photograph—would develop into the primary commercial corridor outside of the square. (Courtesy of Shacklett's Photography/ Southern Heritage Photography.)

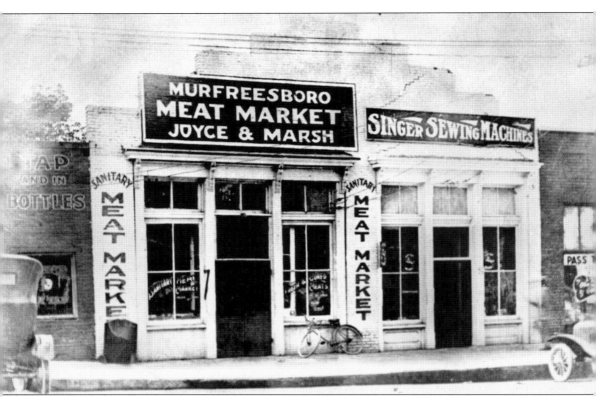

This early-20th-century photograph is a wonderful tutorial on both transportation and commerce. Taken on the square, it shows a bicycle as well as automobiles. These cars were parked straight into the curb and were still free of the dreaded parking meter, which was to arrive at a later time in the century. (It is interesting to note, however, that much of the square's perimeter parking is again free of parking meters.) The Joyce and Marsh Murfreesboro Meat Market was obviously intent upon communicating to the customer its sanitary methods of keeping meat fresh. One must imagine the realities of being a butcher prior to the advent of the freezer or easy refrigeration. To the left is a store's beverage advertisement, noting that one could purchase drinks "on tap" or in bottles. After visiting the Singer sewing machines store to the other side of the meat market, one might also "pass time" per the storefront invitation to the far right of the photograph. (Courtesy of the Mullins family.)

Four

BLUE-RIBBON MEDICINE

Murfreesboro's catalytic growth since the turn of the millennium is in large part due to the health-care industry and the medical community's steep rise in quality and number. The Middle Tennessee region is now able to claim an impressive position of leadership in the arena of quality medical care.

This is far from where the region began. In Depression-era Murfreesboro, Rutherford County played a pivotal role in improving the health of its citizens by virtue of its selection as a target rural community to benefit from the Commonwealth Fund. The New York–based fund's charter was to identify and educate rural communities, especially the children, as to the basics of health care. Local legend has it that Murfreesboro's then claim to maintain a "health department" was key to its being selected. Whatever the Commonwealth Fund's rationale, Murfreesboro and its rural surroundings were the beneficiaries of an amazing infusion of finances and training. And the schoolchildren were actively engaged in the process, as seen by the images that follow.

It is hard to imagine those beginnings in this current technology-driven health-care world. But there was a time not so long ago that the eight daily health rules were written on the blackboard for fourth graders to see and learn for the first time in their young lives. Rural, or "fast," nurses working for the health department had to travel long and lonely distances to the outer reaches of Rutherford County to check on children and their farming families. These people made a true difference in the lives of those they assisted. Much has changed for the better thanks to those early efforts.

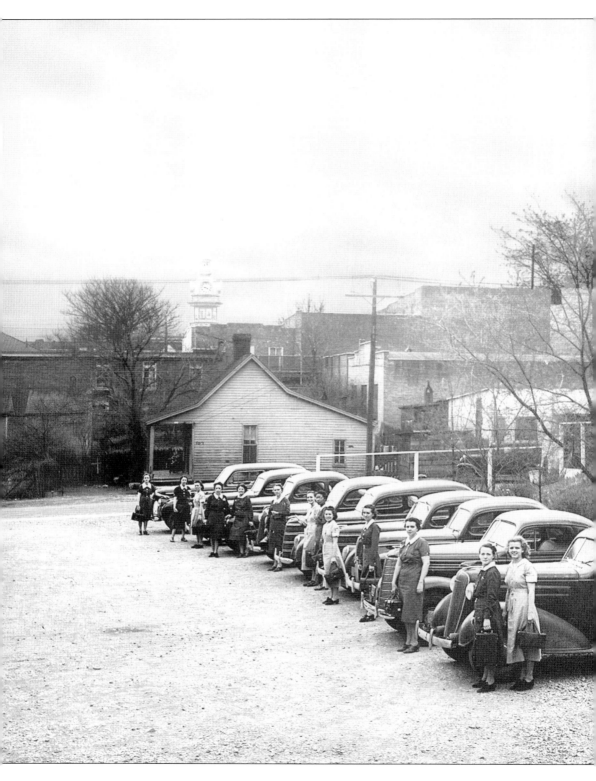

Rutherford County was the beneficiary of the national Commonwealth Fund's study of rural health in the 1920s, in large part because it had created a health department when competing counties had not. The fund was the source of tremendous support in studying and improving health care for the many rural citizens of the area. This image is of rural nurses, or fast nurses, as they were known to differentiate them from their horse-and-buggy predecessors. Here they are standing in the driveway of their employer, the Rutherford County Health Department. The fund provided dependable vehicles for the trek to their assigned rural destinations. The Murfreesboro and Rutherford County medical community grew steadily over the century into what is now an exploding and progressive health-care center for the Middle Tennessee region. (Courtesy of Shacklett's Photography/ Southern Heritage Photography.)

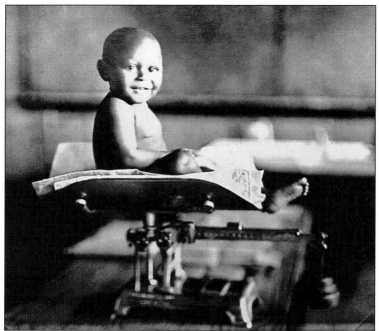

This happy and healthy little boy is being weighed on scales at Bradley Academy as part of the well-being clinic, a good-health campaign resulting from the Commonwealth Fund's study of rural health in Rutherford County in the 1920s. The "blue ribbon campaign" was the area's primary tool for mustering the support of schools and children to meet their daily health-habit requirements. (Courtesy of the Tennessee State Library and Archives.)

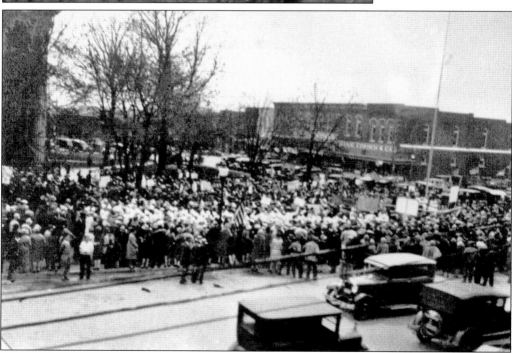

This image is a late-1920s blue-ribbon parade in culmination of a blue-ribbon campaign. A child would receive a blue ribbon and get to march in the parade if they had abided by the health rules for the school year. School students from around the county descended upon Murfreesboro's town square to march in the parade. The best parade group would win the blue-ribbon loving cup. (Courtesy of the Tennessee State Library and Archives.)

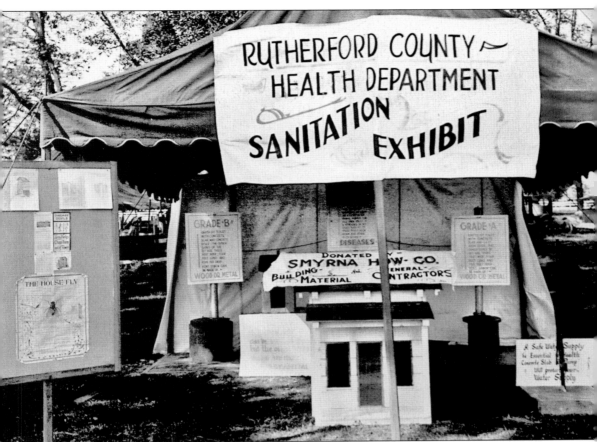

Seen here is a Rutherford County Health Department's sanitation exhibit. The Commonwealth Fund, in partnership with the Rutherford County Health Department, would regularly provide public health demonstrations for its citizens. Its charter was to teach basic hygiene and food preparation. Visible to the left of the photograph are a written tutorial on the housefly and a flier about "disease devils" suggesting, "Lets help chase them out of town." To the lower right is the following warning: "A safe water supply is essential to health. Cement slab and pump will protect your water supply." These public health demonstrations were a vital part of the late-1920s experiment that helped Rutherford County rise above it poverty status. Murfreesboro benefited greatly over time as the headquarters for the Rutherford County Health Department and as the location of the county's first hospital. (Courtesy of the Tennessee State Library and Archives.)

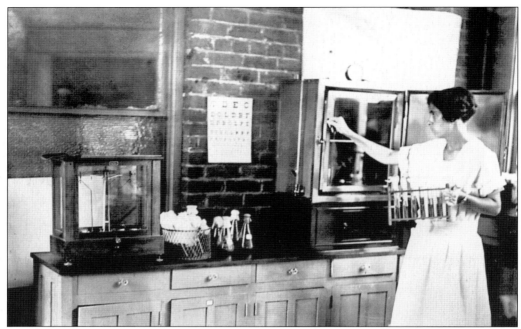

The Commonwealth Fund nurses were employees of the Rutherford County Health Department. This nurse is stocking the medicine shelves of the examining room. The location is likely the hospital or the health department. (Courtesy of the Tennessee State Library and Archives.)

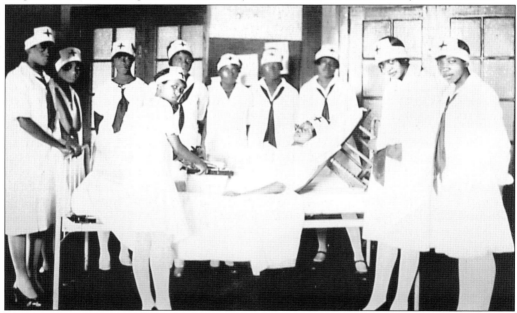

These African American nurses are being trained at Bradley Academy. A position as a trained nurse for the Rutherford County Health Department was a highly sought-after position. These nurses were likely also functioning as fast nurses who went out into the rural areas around Murfreesboro to serve the African American community. (Courtesy of the Tennessee State Library and Archives.)

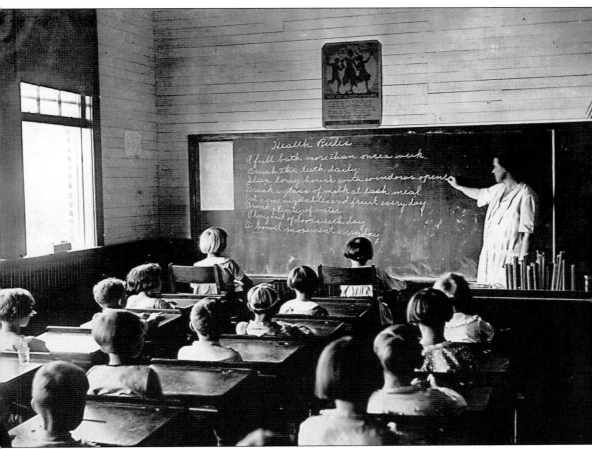

The Commonwealth Fund utilized the Rutherford County schools—and more specifically, its teachers—to educate children and their families about health and hygiene. In large part because of resistance to change among the older population, the Commonwealth Fund in its wisdom elected to focus on the children. Seen here is an elementary teacher reviewing the eight daily rules of good health. The young students were required to master these rules and practice them on a daily basis in order to be eligible for the blue-ribbon prize awarded at the end of the school year. The rules on the blackboard are as follows: "Take a bath more than once a week, brush teeth daily, sleep long hours with open windows, play outside, eat a piece of fruit everyday, drink plenty of water, drink a glass of milk with every meal, and have a bowel movement every day." (Courtesy of the Tennessee State Library and Archives.)

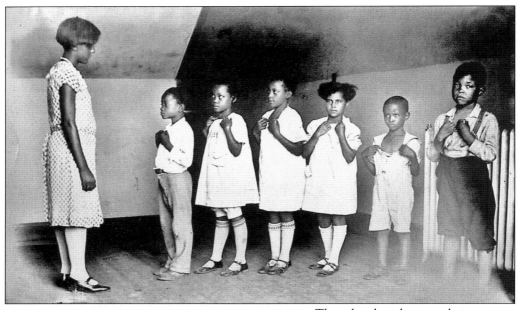

These local students are being checked for mumps. The Commonwealth Fund administrators were pleasantly surprised to discover that the African American community was receptive to and most willing to participate in the fund's health program for the students and their families. (Courtesy of the Tennessee State Library and Archives.)

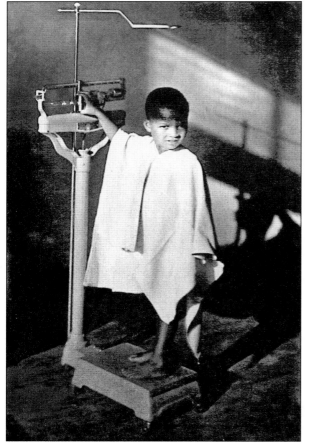

This photograph of a young boy was most likely taken at the Rutherford County Health Department or at Bradley Academy. The usual procedure for the Commonwealth Fund health examinations began with the scales. By checking the children's weight and height, the nurses could start to determine the child's state of health and nutritional needs. (Courtesy of the Tennessee State Library and Archives.)

The concept of "rural" in the early part of the 20th century was a far cry from its connotation 100 years later. A rural farm could have been within a mile from the square in 1920. Poverty was the norm, not the exception. This photograph of rural children is indicative of the socioeconomic realities of most of the children in Rutherford County at that time. (Courtesy of the Tennessee State Library and Archives.)

Prior to the consolidation of the school systems in Rutherford County, there was no differentiation between a city school and a county school. Funds were obviously an issue with regard to supplies and desks. Note the two young girls sharing one desk. (Courtesy of the Tennessee State Library and Archives.)

The photograph depicts children at the health department waiting their turn for a shot. The Rutherford County Health Department's implementation of a system providing vaccinations against disease was a tremendous leap in the general medical welfare of local children. The relatively high death rate of children had been a horrible reality in the preceding century. (Courtesy of the Tennessee State Library and Archives.)

This is an intriguing image of children in the classroom during the Commonwealth Fund–era of Rutherford County. Each of them is holding a container, perhaps a liquid medicine or vitamin mixture. The classroom was the primary method of reaching all the children in an effective way. The children took home to their extended family the good health they were learning in class. (Courtesy of the Tennessee State Library and Archives.)

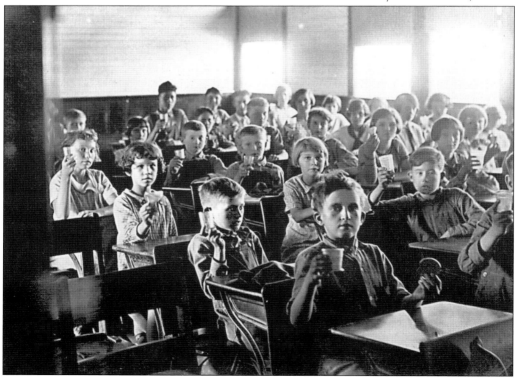

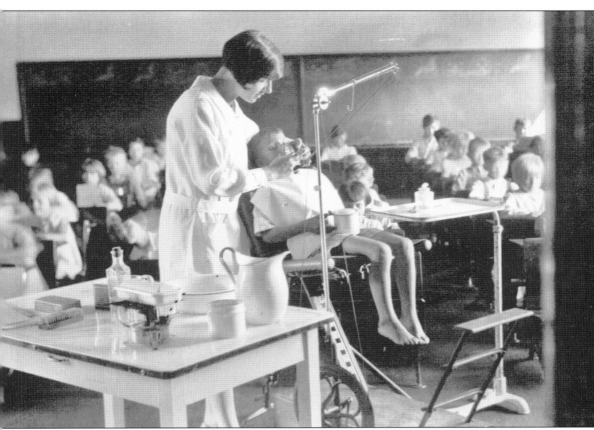

This amazing image demonstrates the determination of the health department and teachers to better the medical and dental health of the children. The rural families were often not able to bring their children to the dentist. It was arguably all that they could do to get them into the classroom. The solution was to have the dentist and assistant come to the school. They would work on the children's teeth during class, as seen here. (Courtesy of the Tennessee State Library and Archives.)

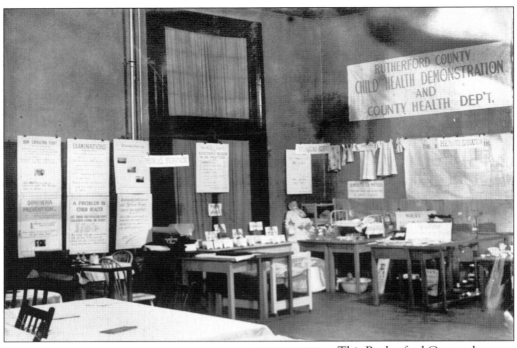

Has Your Child Won a Decoration in the Army of Health?

1. Is His Birth Registered?
2. Are His Habits Satisfactory?
3. Is He Free from Physical Defects?
4. Is He Protected against { Diptheria? Typhoid Fever? Smallpox? }

The above qualifications entitle children from two to six years of age to a Pre-school Blue Ribbon.

HEALTH CENTER POSTER

This Rutherford County banner announcing a child health demonstration by the health department was an effective tool in getting the word out to families. The Commonwealth Fund program utilized posters and banners as primary tools to reach those in need of care and education. (Courtesy of the Tennessee State Library and Archives.)

Posters were effective in reaching the parents on the subject of their children's health. Here a positive response to the four questions achieves the goal of a preschool blue ribbon. The Rutherford County Health Department's ingenious blue-ribbon prize was a powerful stimulus for both children and their parents in exercising good health habits. (Courtesy of the Tennessee State Library and Archives.)

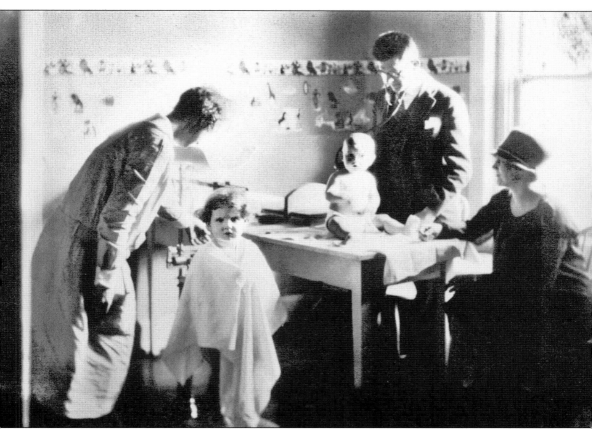

This wonderful photograph taken by Dr. Harry S. Mustard shows a mother and two children during the children's health examination. The nurse is weighing the preschooler as mother and baby look on. The habits established with regular examinations such as these changed the health habits of an entire generation and all of those that followed. (Courtesy of the Tennessee State Library and Archives.)

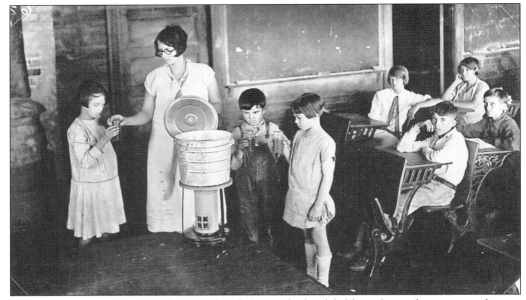

Here the teacher scoops out a hot soup lunch for rural schoolchildren. Some things never change. A hot lunch for a young child is still a challenge and a critical part of their well-being. Note the manner of heating the soup in the classroom. The teacher has placed the metal bucket of soup on top of a flame burner. (Courtesy of the Tennessee State Library and Archives.)

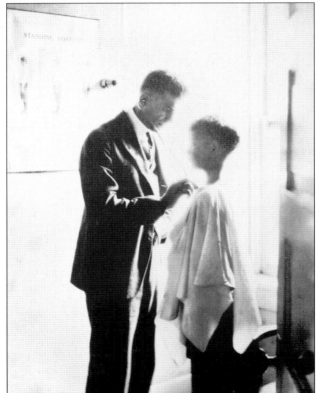

This is most likely a photograph taken by Dr. Harry S. Mustard. The Mustard collection consists of Dr. Mustard's photographs during the late 1920s. Here a doctor has come to the school to examine the children. He listens to the heartbeat and breathing of his schoolboy patient. (Courtesy of the Tennessee State Library and Archives.)

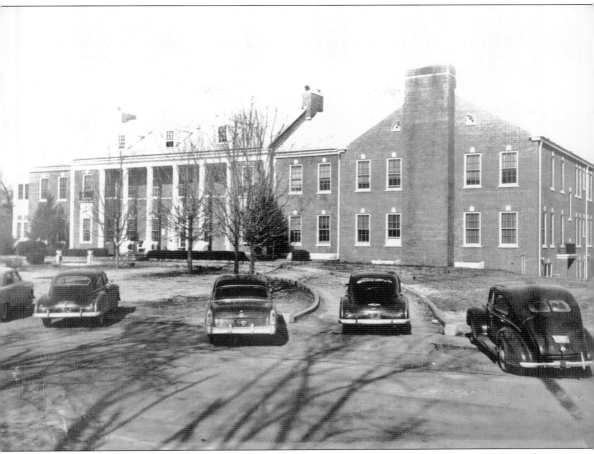

Rutherford Hospital, as seen here in the 1940s, was built with financial assistance from the Commonwealth Fund. It was the first partnership of a hospital and health department in the nation. Working side-by-side, the Rutherford County Health Department and the Rutherford Hospital paved the way for Murfreesboro and its surroundings to improve exponentially in medical care. That improvement continues to the 21st century with the addition of the Medical Parkway corridor. The massive growth in the medical community of Middle Tennessee would not exist were it not for its beginnings a century prior. The Commonwealth Fund's selection of Rutherford County for its rural health program changed the destiny of Murfreesboro. (Courtesy of the Tennessee State Library and Archives.)

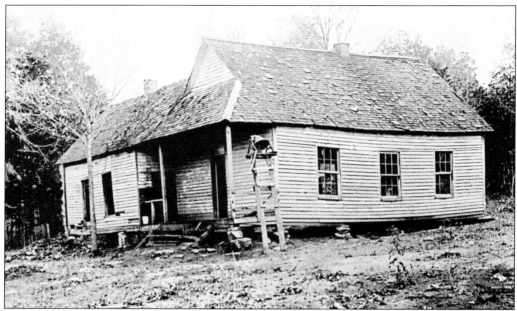

The photograph of Lowe School shows pre-consolidation education in Rutherford County. This small rural schoolhouse preceded the time of city- and county-funded schools or what was referred to as the consolidation of schools. It is likely that this was a private school that required rural families pay some form of tuition. (Courtesy of the Tennessee State Library and Archives.)

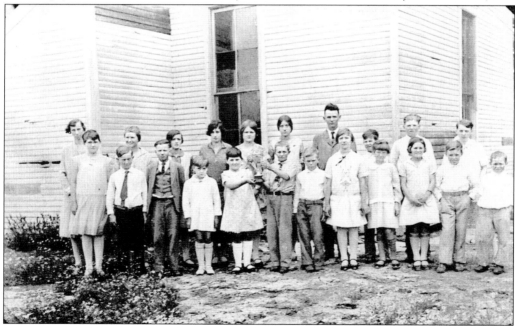

These grammar school students are proudly holding their hard-won blue-ribbon campaign loving cup. The loving cup was awarded to the best parade team of students marching in the annual blue-ribbon parade. Each of those marching had been acknowledged by their school as diligently practicing the eight daily health rules. (Courtesy of the Tennessee State Library and Archives.)

Five

ACADEMICS
AND AVIATION

Educational institutions have defined the community of Murfreesboro from its inception. Elementary, secondary, and college-level institutions of note range from Bradley Academy, the Tennessee Normal School, and Tennessee College for Women, to the subsequently named Tennessee State Teachers College and ultimately Middle Tennessee State University, as it is named today.

Education has been a major emphasis to the citizens of Murfreesboro for its almost two centuries of growth. Bradley Academy was the alma mater of Pres. James K. Polk. Soule College was the alma mater of Jean Faircloth MacArthur. And the sky is now the limit with the largest undergraduate population in the state attending Middle Tennessee State University.

Murfreesboro and Rutherford County also have a remarkable aviation history. Sky Harbor Airport, located in nearby Smyrna, was at one time the sole airport serving Nashville and the surrounding region. In addition, the Murfreesboro Flying School was available to students of the then-named Middle Tennessee State College. Those early efforts morphed over the latter part of the 20th century into the top-five-ranked aviation program at Middle Tennessee State University. Murfreesboro Airport is the program's "laboratory."

In 1946, the *Midlander* yearbook included the following advertisement from the Murfreesboro Flying Service: "Leadership of M.T.S.C. in this flight age is typified by overwhelming reception given by both the college students, local fliers and itinerant pilots from all over the Unites States. It is a proven fact that four out of five have an urge to fly but all too often it remains only an urge. It is our sincere desire to help you overcome the obstacles."

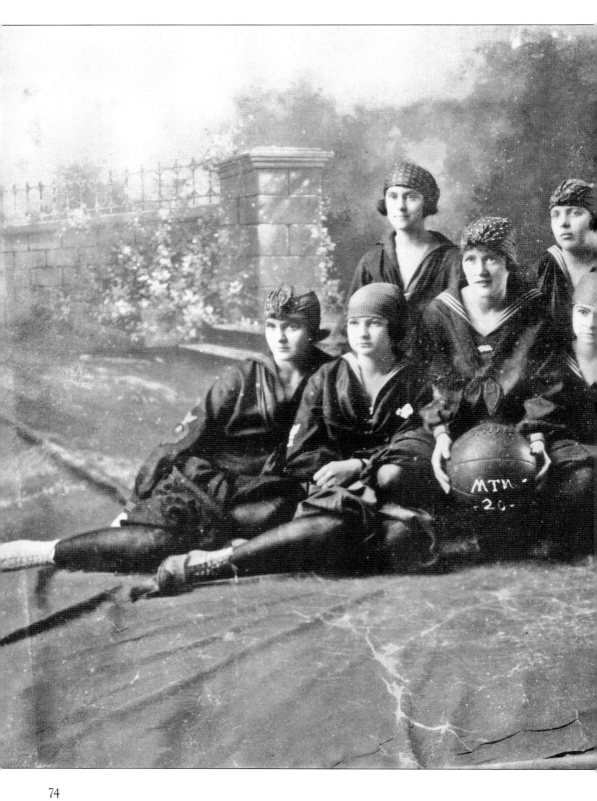

Early academic institutions in Murfreesboro included the religion-affiliated Tennessee College for Women and the state-funded Tennessee State Teacher's College, which had begun as the Middle Tennessee Normal School and would ultimately become Middle Tennessee State University. This is the 1920 official team photograph of the Middle Tennessee Normal School's women's basketball team. (Courtesy of the Albert Gore Research Center, Middle Tennessee State University.)

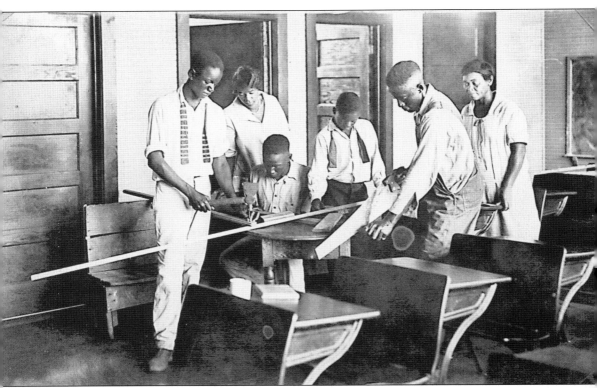

Bradley Academy was a city school formed in the early 1800s, and its alumni include James K. Polk and Sarah Childress Polk. In 1884, the school began its 75-year legacy as an elementary and secondary school for the African American community. These Bradley high school students are learning trades from their instructor in the background. (Courtesy of the Tennessee State Library and Archives.)

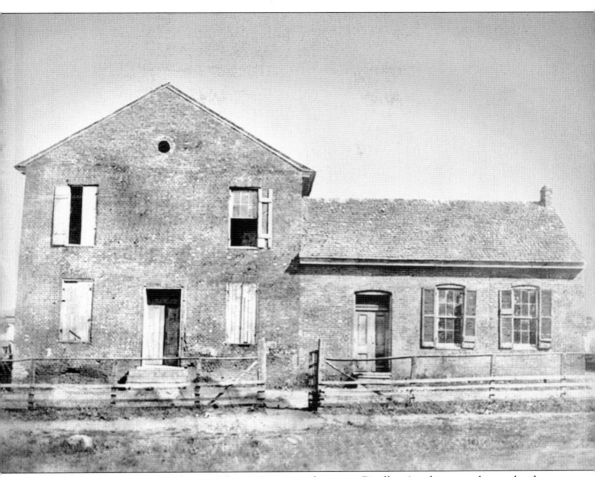

Now a museum to Murfreesboro's African American heritage, Bradley Academy was begun by the Tennessee Legislature in 1806, three years after the county was founded. The original building, shown here, no longer stands but educated President James K. Polk and served as a hospital during the Civil War. Students paid $24 a session and were required to provide firewood. The early curriculum included English, Latin, Greek, arithmetic, logic, and literature. (Courtesy of Shacklett's Photography/ Southern Heritage Photography.)

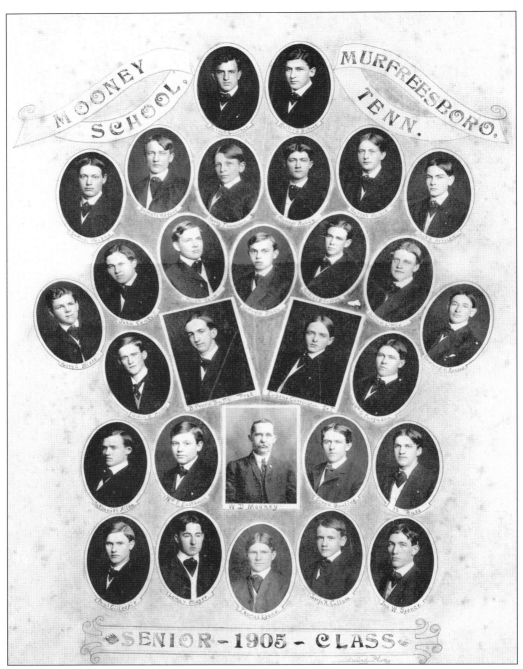

Many Murfreesboro students were educated at private schools, such as Mooney. Located near the town square, the Mooney School was founded by W. D. Mooney, a scholar of the highest order, to prepare young men for life. This graduating class of 1905 studied Greek and Latin as well as participating in football, tennis, and swimming. Mooney's graduates often went on to study at Harvard, West Point, Yale, and Vanderbilt. (Courtesy of the Lee Lively family and the Southern School of Photography.)

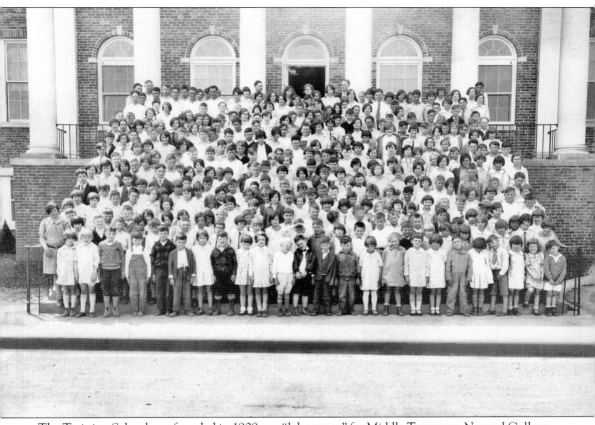

The Training School was founded in 1909 as a "laboratory" for Middle Tennessee Normal College students in the education department. Middle Tennessee Normal was a teaching school. It has been called the Demonstration School, Training School, and the Campus School. In 1985, it was named after Homer Pittard, an educator, university administrator, and local historian. Students were from nearby neighborhoods and also the children of college professors and employees. (Courtesy of the Rutherford County Documentary collection.)

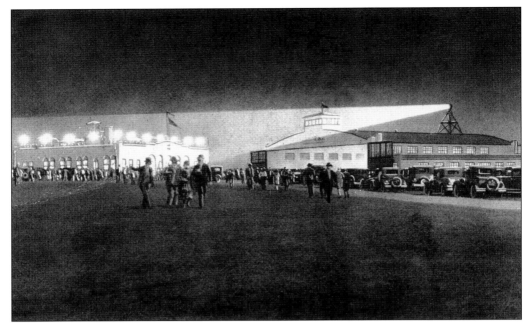

This postcard celebrated a unique setting on the Murfreesboro landscape. It was the official Nashville airport. When someone wanted to fly in and out of Nashville between 1929 and 1937, they came through Murfreesboro. This postcard shows local socialites attending an evening event at this world-class airport. Human flight was a relatively new experience, but the atmosphere of a regional airport provided Murfreesboro with both convenience and adventure. (Courtesy of Bill Jakes.)

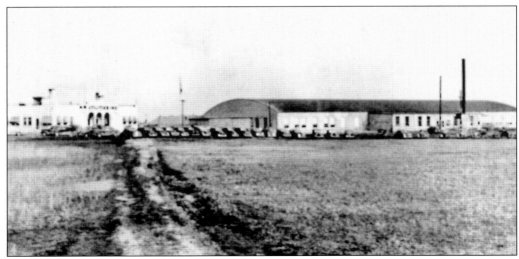

Very few photographs are known to exist of Sky Harbor, but this rare image reveals an active and robust facility. The 1930s automobiles surround the terminal to the left and the main hangar on the right. The title "Air Utilities Inc" welcomed visitors, pilots, mechanics, and the curious alike. (Courtesy of the Rutherford County Documentary collection.)

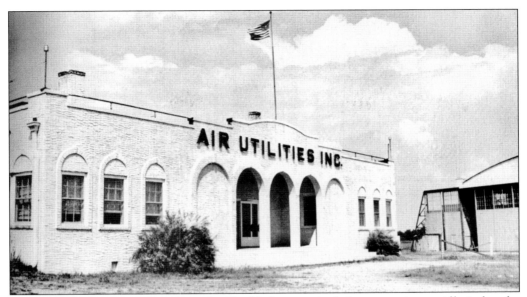

A flag with only 48 stars flies above the Sky Harbor terminal, demonstrating a stiff wind at the main airport that serviced Nashville as well as Murfreesboro in the 1930s. Sky Harbor dwelt between the Old Nashville Highway (US 41) and the railroad. The whitewashed structure was surrounded by weather-detection instruments, such as the barometers at the corners of the roof. (Courtesy of the Rutherford County Documentary collection.)

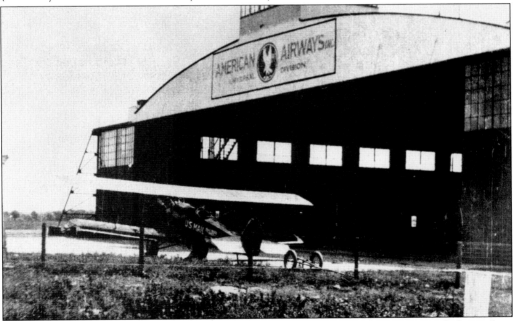

The U.S. Mail biplane in the foreground delivered mail throughout the region much faster than automobiles or trains. Maintenance and repairs took place in the American Airways hangar in the background. American Airways would later become American Airlines. The 118th Airlift Wing and 105th Airlift Squadron called Sky Harbor home for a short period of time as well. (Courtesy of the DeGeorge and Meshotto families.)

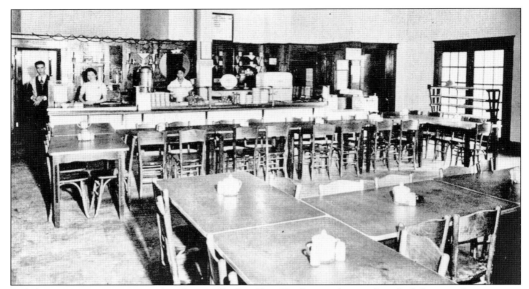

While empty now, except for the staff, the Sky Harbor cafeteria bustled during departures, arrivals, and at lunchtime. There's no doubt cafeteria patrons enjoyed good Southern cooking while viewing planes coming and going on the nearby landing field. Such accommodations are expected at modern airports, but this was quite a treat in 1930s Middle Tennessee. (Courtesy of the Rutherford County Documentary collection.)

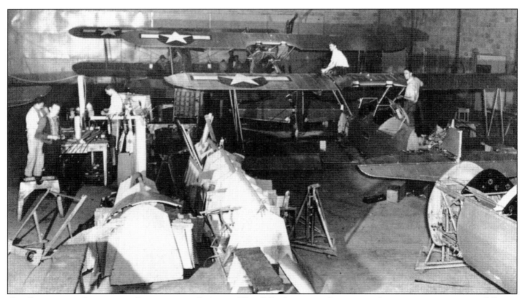

A plane is only as good as its mechanic. Sky Harbor airplane mechanics are captured here providing maintenance and building biplanes in the main hangar. Every bolt, rivet, and gauge has to work properly to ensure the safety of the crew, passengers, and the folks on the ground. (Courtesy of the Rutherford County Documentary collection.)

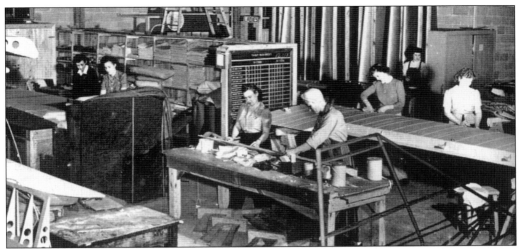

Say hello to Rosie the Riveter! These talented ladies are seen assembling airplane wings in the main hangar. Made with modern tools and technology, these wings provided the needed lift and stability for flight. No doubt the manufacturing skills of these women would be put to use in a few short years as America entered World War II. (Courtesy of the Rutherford County Documentary collection.)

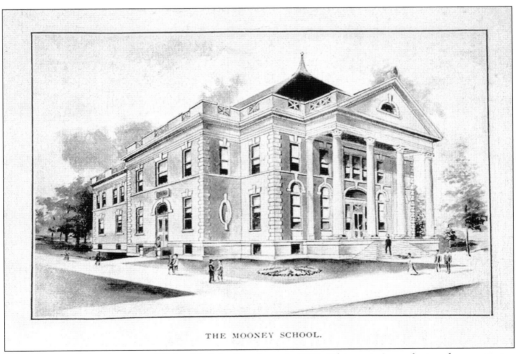

THE MOONEY SCHOOL.

The Mooney School was established in Murfreesboro in 1901. This artist's rendering demonstrates the atmosphere created by the Mooney School. Students, professors, and administrators undoubtedly enjoyed the stylings of classical architecture, which made the school one of the premier structures in town. (Courtesy of Jim Laughlin.)

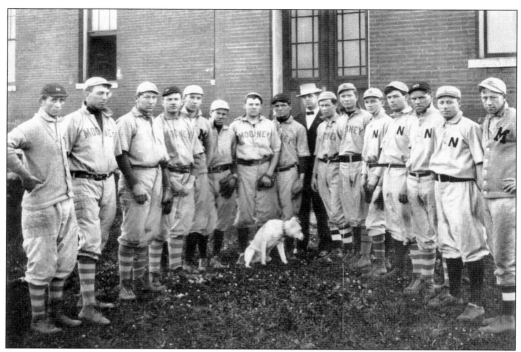

The Mooney School baseball team is shown wearing uniforms proudly bearing the Mooney name. Pictured at center is the team's canine mascot. This yearbook photograph was taken during the 1920s. (Courtesy of the Rutherford County Documentary collection.)

While W. D. Mooney founded several Tennessee schools, his legacy is not in buildings or institutions but in the enriched lives of the young men he educated. During his more than 50 years in education, Mooney founded the Battle Ground Academy in Franklin, Tennessee, and the Mooney Schools in Murfreesboro and Harriman, Tennessee. After his Franklin school burned down in 1901, he moved Murfreesboro to reestablish his school. Tragedy would strike again when a friend failed to pay a debt guaranteed by Mooney, which left him penniless. (Courtesy of the Rutherford County Documentary collection.)

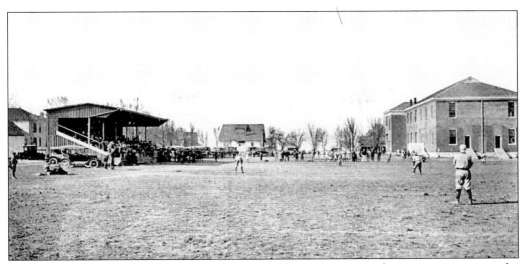

Play ball! The often-heard shout of an umpire, coach, or player started many a contest near the famed Mooney School on Kerr's Field. The Mooney boys were probably playing a team from another local prep school, such as the Webb School or Battle Ground Academy. The lines on the field indicate that football was also played here. W. D. Mooney is credited for introducing football to Murfreesboro. (Courtesy of the Leo Ferrell family.)

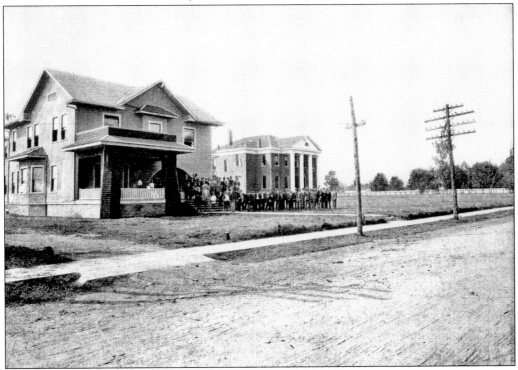

Seen just off East Main Street outside of a dormitory are the parents, students, and staff of the Mooney School. The main building proudly sits in the background. The telegraph and electricity lines run beside the dirt road. The dormitory in the foreground still exists as a private home. (Courtesy of Bill Jakes.)

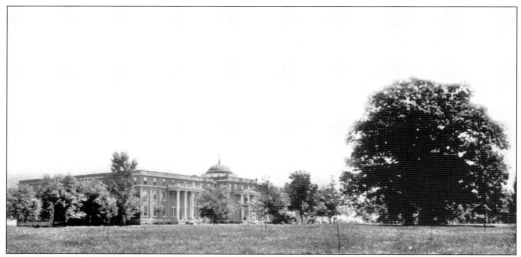

Established in 1907 just off East Main Street and only a few blocks from downtown Murfreesboro, the Women's College was built by local Baptists. Financial difficulties forced the unique institution to close its doors in 1946 and merge with Cumberland University in Lebanon, Tennessee, only 25 miles away. During its existence, the college provided higher education for young women who would otherwise not have access to a college. (Courtesy of the Rutherford County Documentary collection.)

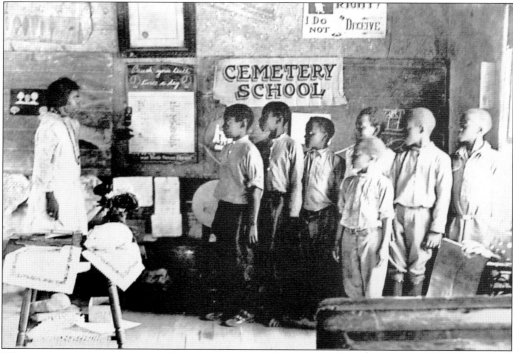

While reviewing health rules, these late-1920s students of the Cemetery School were receiving an education often denied to descendents of former slaves. Local schoolhouses like this one were often operated and funded by local communities. Notice the admonishments to "not deceive" and "brush your teeth twice a day." (Courtesy of the Tennessee State Library and Archives.)

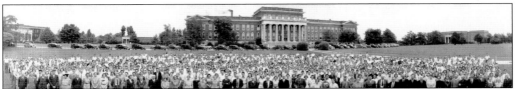

In 1939, the Middle Tennessee State Teachers College had grown dramatically, which is displayed in a rare Lee Lively panoramic photograph. The staff, professors, and students are shown in the heart of campus. Behind the group is Old Kirksey Main, which remains both a historical and functional part of the 20,000-plus-student university, known today as Middle Tennessee State University. (Courtesy of the Lee Lively family and the Southern School of Photography.)

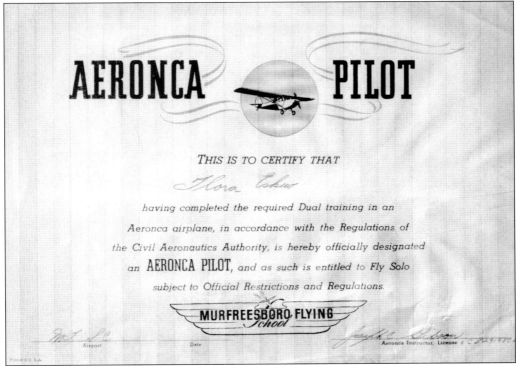

The women's aviation club at Middle Tennessee State College was organized January 10, 1946, by students taking the aeronautics course. Its members received a certificate, such as this one belonging to pilot Flora Eskew, from the Murfreesboro Flying School once trained to fly solo. A decade later, MTSC had to lease space at Murfreesboro airport due to the growth of its aeronautics program. (Courtesy of the Wagnon Collection.)

Warm weather filled the days, while seasoned professors spent time with their students on the growing campus of the Middle Tennessee State Teachers College. Established in 1911 just 2.5 miles from downtown Murfreesboro and a half-mile from the geographic center of the state, the college became the center for teaching eager students how to teach children. The MTSTC Alumni Center in the background provided a place for repose and refreshment. (Courtesy of the Albert Gore Research Center, Middle Tennessee State University.)

These dapper young students seem eager to learn and grateful for their school. Well actually, they are probably like every other student in history and are wishing they were playing, but there's no doubt the local Murfreesboro grammar school provided a good atmosphere for learning about math and English as well as about life. Sailor outfits were obviously popular for both boys and girls. (Courtesy of the Rutherford County Documentary collection.)

Six

GATHERINGS AND GATHERING PLACES

The images that follow reflect local people brought together. The reasons they may have congregated vary wildly and range from horses to catfish, from worship to a raging fire.

One major gathering of great significance in history was the celebration of the opening of the railroad from Nashville to Murfreesboro in 1845. As Thomas N. Johns Sr. of Nashville wrote in his report of the event, "(T)he crowd was generally estimated at ten thousand. It was certainly a very large and a very happy one. . . . Murfreesborough did herself high honor in the preparations for feasting so large a crowd and we are sure that her hospitalities will long be remembered by the citizens of Nashville."

Col. Vernon K. Stevenson was the visionary who dreamed of a railroad stretching from the Northeast to the Southern seaboard cities of Charleston and Savannah, with the center of the system being Middle Tennessee. Thus was born the Nashville and Chattanooga Railroad Company, or N&C Railroad, the first bona fide railroad in Tennessee.

That railroad was indeed remembered a mere 17 years later when the Battle of Stones River forced the Confederates to yield that railway to Union control. General Sherman in essence followed the railroad to the sea. Today freight cars barrel through Murfreesboro day and night on the non-passenger railroad headed to and from the sea.

The night train roaring past the once active Murfreesboro Depot is the very best sound in the world. It is a reminder of a time when people were thrilled to be able to travel the 30 miles from Nashville to Murfreesboro without a horse-and-buggy or a boat. They gathered instead on the train.

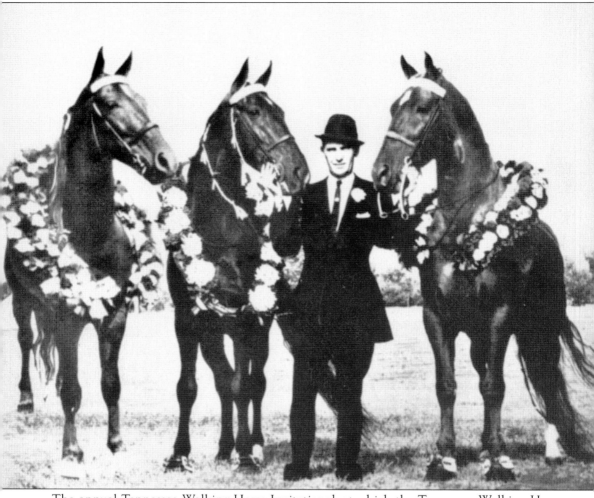

The annual Tennessee Walking Horse Invitational, at which the Tennessee Walking Horse Grand Champion is named, has been a huge draw to Middle Tennessee for many decades. The contest is a demanding, high-level competition among some of the finest horses and trainers in the world. In 1963, Tennessee Walking Horse owner Sam Paschal made history with his dynasty of three successive generations of Grand Champions. Midnight Sun was Grand Champion in 1945, Setting Sun was the winner in 1958, and Sun's Delight completed the trilogy in 1963. These magnificent horses, whose lives spanned two decades, are shown here together with Sam, thanks to the magic of this composite photograph. Today Middle Tennessee State University's magnificent new equestrian center at Miller Coliseum is the site of these competitions. (Courtesy of the Rutherford County Documentary collection.)

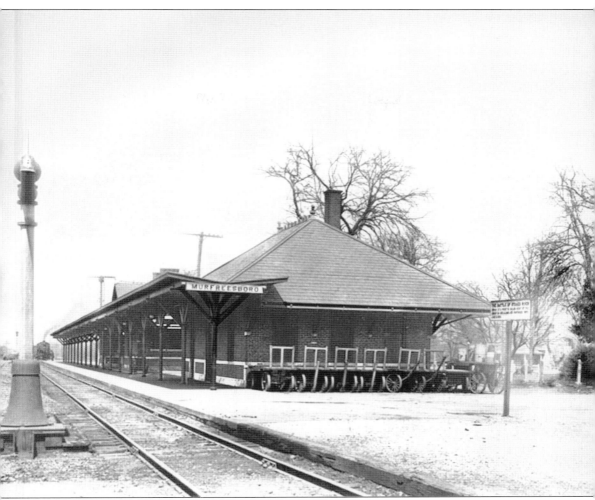

Murfreesboro Station still stands on West Main Street, as it did when this photograph was taken. Now it watches as freight trains rumble past. It was a station serving passenger rail as well. Note the hand pushcarts on the side of the station for loading and unloading cargo. Most of the cargo arriving at Murfreesboro would have been the U.S. mail. The Tennessee town of Lebanon is located in Wilson County, the northern contiguous county to Rutherford County. In 2006, a passenger rail line opened, providing daily round-trips for locals commuting from Nashville to Lebanon. The commuter rail line is called the Music City Star. Many train lovers and those simply tired of interstate commuting are full of the hope that Murfreesboro will be next to achieve this. (Courtesy of the Leo Ferrell family.)

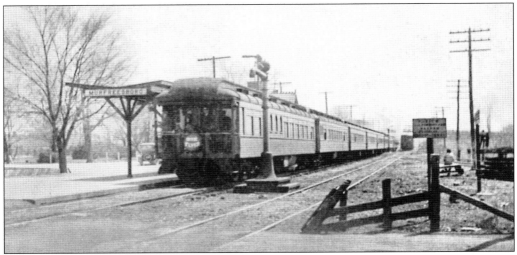

Here the Dixie Flyer arrives at Murfreesboro Station. Note the conductor in full uniform on the back platform. He is likely checking the time on his Hamilton railroad watch. The train looks to be a late-1800s or early-1900s model. Note the automobile waiting in the dusty parking lot. (Courtesy of the Rutherford County Documentary collection.)

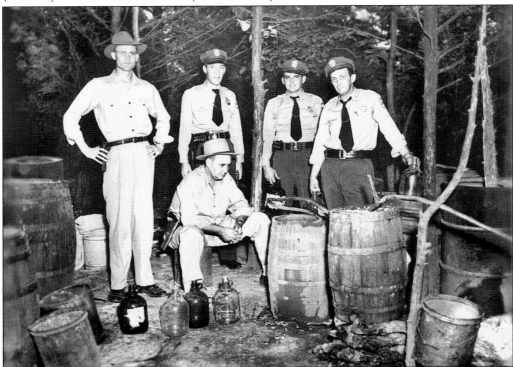

The 1950s were a turning point for Murfreesboro in many ways because of its growth as part of Middle Tennessee, not the least of which was increased law enforcement with regard to certain illegally distilled substances—namely moonshine. Seen here are the officials and their contraband, its "manufacturers" forewarned and long gone into the woods at night. (Courtesy of Shacklett's Photography/ Southern Heritage Photography.)

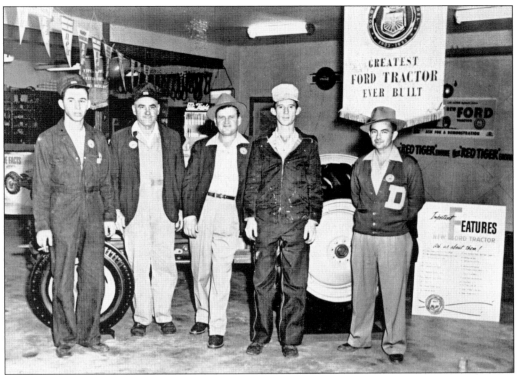

As the rich and fertile soil of Middle Tennessee enriched the farming community of Murfreesboro and Rutherford County, so followed farming equipment manufacturers and dealers. The tractor dealership on West Main Street was a thriving concern. It was obviously a Ford tractor dealer, and the sign on the wall exclaims the virtues of the Red Tiger engine. (Courtesy of the Dement family.)

These unidentified gentlemen have congregated at the West Main Street tractor dealership. The marvels of a new tractor acted as a magnet for farmers when they came to town. The Murfreesboro tractor dealership was a must-stop gathering place for the rural community on sojourns into town. (Courtesy of the Dement family.)

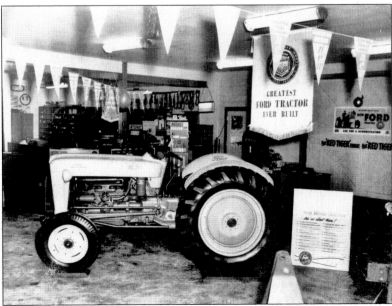

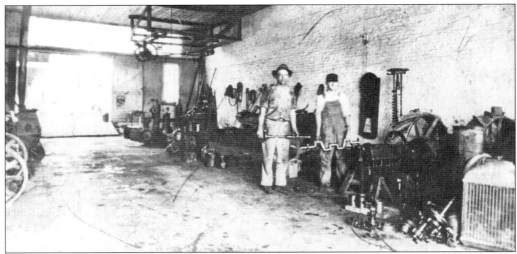

A machine shop was of critical importance in the new era of automobiles. Automobile repairs were done in a machine shop such as this one located in downtown Murfreesboro in the first part of the 20th century. Early vehicles were highly unreliable and required constant repair by machine men, such as the two pictured here. (Courtesy of the Rutherford County Documentary collection.)

Many of the former horse stables were converted into car dealerships. As the horse fell away from the priority mode of transportation, cars took over. Here a gathering of gentlemen is seen in front of the Jackson Chevrolet dealership. The dealership facilities were aesthetically pleasing and would have the space needed from the building's stable days. (Courtesy of the Rutherford County Documentary collection.)

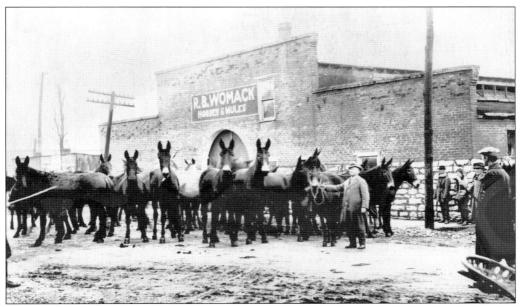

B. B. "Dick" Womack was a well-established dealer and shipper of mules. Middle Tennessee was once known as the mule capital of the South. The Womack Stables were located off of West Main Street near the square. The building is reportedly still standing. (Courtesy of the Rutherford County Documentary collection.)

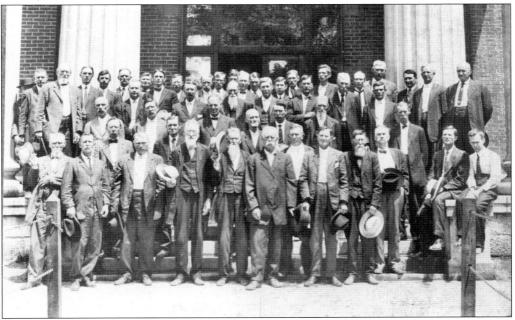

Here Murfreesboro lawyers, judges, constables, and courthouse workers, both the young and the not so young, are all assembled on the steps of the Rutherford County Courthouse. The great stone pillars shown to each side of the photograph still frame the entrance to the courthouse today. The courthouse square has always been and is to date surrounded by law offices. (Courtesy of the Rutherford County Documentary collection.)

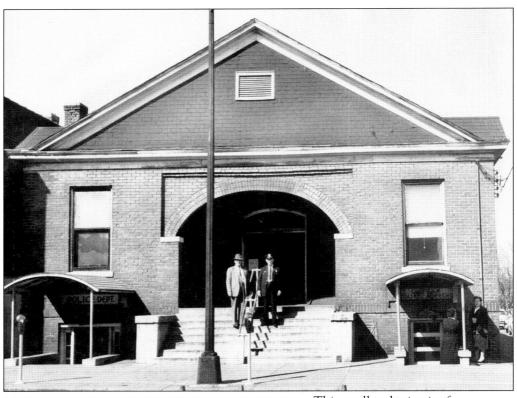

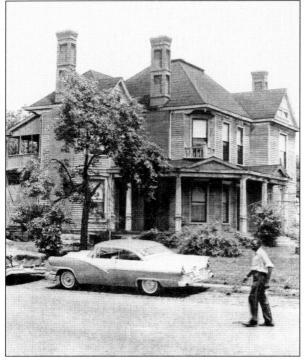

This small gathering is of a policeman and a civilian standing on the steps of the first city hall. The structure has also served as a Presbyterian church. The police department may have been stationed within the same structure at the time of this photograph. Today the police department is adjacent to the city complex on Church Street at the entrance to the south side of the square. (Courtesy of the H. O. Todd family.)

Shown here in the mid-20th century, the Dudley Fletcher home was once one of the largest homes in Murfreesboro. Sadly it no longer exists. Most of the great homes of Murfreesboro, such as the one in this photograph, have been gathered in the book *Hearthstones*, published by the Oaklands Association. (Courtesy of the Rutherford County Documentary collection.)

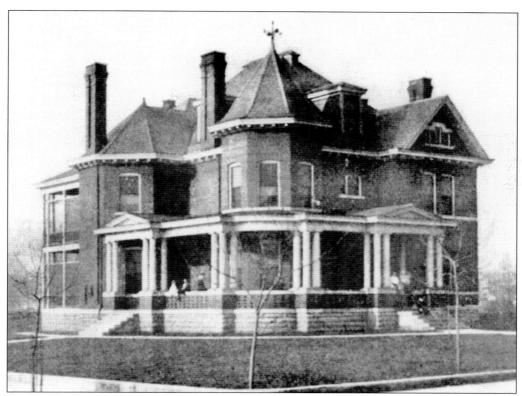

Pictured here is one of the grand historic homes of Murfreesboro. Located on East Main Street, the corridor between the square and the MTSU campus, the Byrn-Roberts home has now become a gathering place for visitors to Murfreesboro. The Byrn-Roberts Inn was transformed into a bed-and-breakfast. (Courtesy of Bill Jakes.)

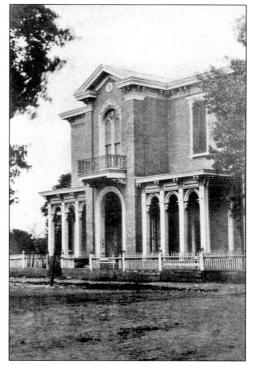

The women's club is located just off of the square at Academy and College Streets. Built in 1856 by Dr. William T. Baskett as his home, this historic building has been preserved and continues to function as a gathering place for the women of Murfreesboro. It has served as the home of the Murfreesboro Women's Club since 1916. Its club library has housed the works of many local authors, including those of Mary Noailles Murfree. (Courtesy of Bill Jakes.)

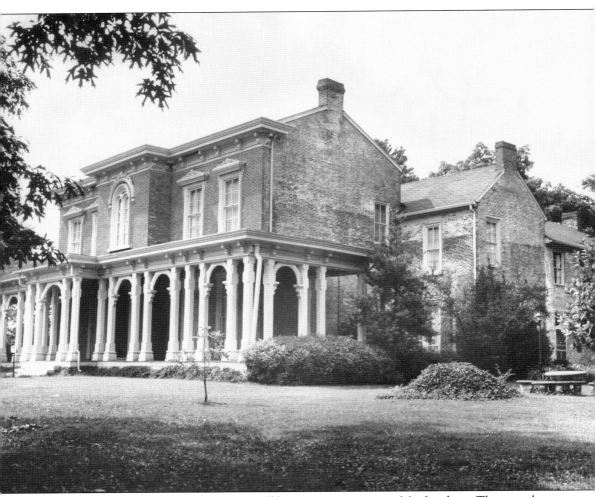

Oaklands Mansion is the touchstone for all historic preservation in Murfreesboro. This great home and grounds—originally called Oak Manor Plantation—covered 1,500 acres and had a formal driveway approximately one mile in length. It is now known as Maney Avenue. The plantation was formed in 1812 by Sallie Murfree Maney and her husband, Dr. James Maney, one of the first doctors in Rutherford County and Murfreesboro. The Civil War came to the plantation when Nathan Bedford Forrest ambushed Union troops who had encamped by the natural springs on the plantation, temporarily wresting the town from Union control. Dr. Maney took the Union commander injured on the plantation, Col. William Duffield, into his home for medical care. (Courtesy of Bill Jakes.)

The Stones River has always played a central role in the history of Murfreesboro, both in its physical layout in its early formation and as a source of recreation and enjoyment by its citizenry. This gathering of fishermen shows off their trophy, the largest catfish on record ever caught in Stones River. (Courtesy of Shacklett's Photography/ Southern Heritage Photography.)

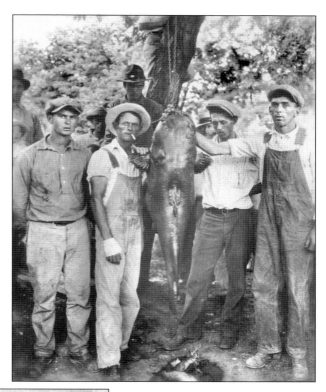

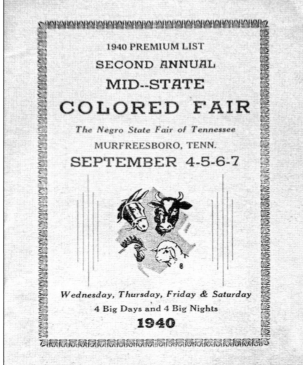

This 1940 poster is an example of segregated Murfreesboro prior to the civil rights advances, which would commence in the subsequent decade. Here the four-day segregated September fair appears to encompass the display of barnyard animals, as evidenced by the poster drawing of a horse, bull, rooster, and lamb. (Courtesy of Jim Laughlin.)

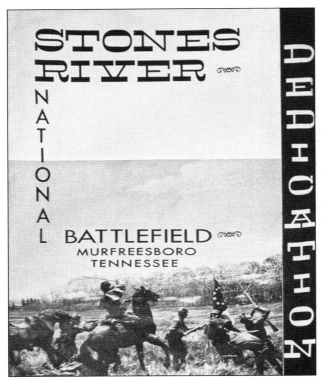

The U.S. Department of the Interior's National Park Service now protects and operates the Stones River National Battlefield. This image is an early poster advertising the original local dedication ceremony. The battlefield is a mecca for students of the Civil War and provides a museum and bookstore, lectures by its knowledgeable park rangers, and reenactments of the Battle of Stones River. (Courtesy of Jim Laughlin.)

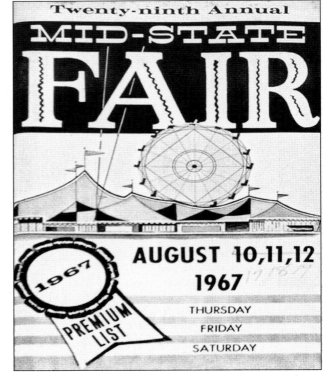

Fast-forward from the Mid-State Colored Fair of 1940, and one has arrived at its August 1967 successor. Here the fairground advertisement is a bit more exciting. Instead of sketches of barnyard animals, the advertisers have advanced to the more enticing images of circus tents and a Ferris wheel. (Courtesy of Jim Laughlin.)

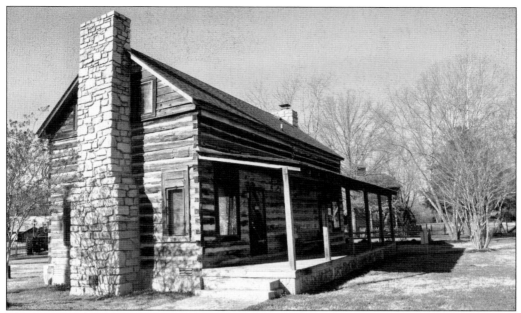

The ramshackle village of Minkslide was once settled along the banks of Stones River's tributary Lytle Creek. The Bottoms was ultimately razed in the mid-20th century. In its place is the recreated pioneer village named in honor of the town's original name, Cannonsburgh. Pictured here is the visitor's center, the site of many cultural events celebrated year-round at Murfreesboro. (Courtesy of the Rutherford County Documentary collection.)

Mills were common in Murfreesboro and its environs given the region's shallow waters and rocky terrain. The mills were also a common meeting place. Pictured here is the Conqueror Flour Mill. Another flour mill of note was Ransom Brothers and Company, which was, according to the 1923 handbook of Murfreesboro and Rutherford County, one of the wealthiest cotton and grain dealer firms in the South. (Courtesy of the Rutherford County Documentary collection.)

Made From Selected Winter Wheat

CONQUEROR GRAHAM FLOUR

"ASK THE WOMAN WHO BAKES IT"
MANUFACTURED BY
MURFREESBORO MILL COMPANY
MURFREESBORO, TENN.

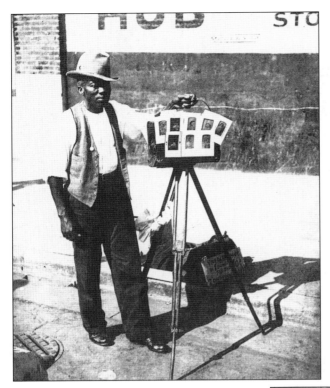

Images remain the driving force of memory and history. This man is plying his trade as a "distributor" of photographic images on the streets of downtown Murfreesboro. Note the placard is his primary marketing tool. (Courtesy of the Leo Ferrell family.)

Pictured here are proprietor and customer visiting in a Murfreesboro store selling a cross section of basic needs. These were the days when one requested the items needed, and the proprietor would retrieve them from the shelves behind the counter—via ladder in some instances. Note the hard candies placed prominently on the front counter. (Courtesy of Jim Laughlin.)

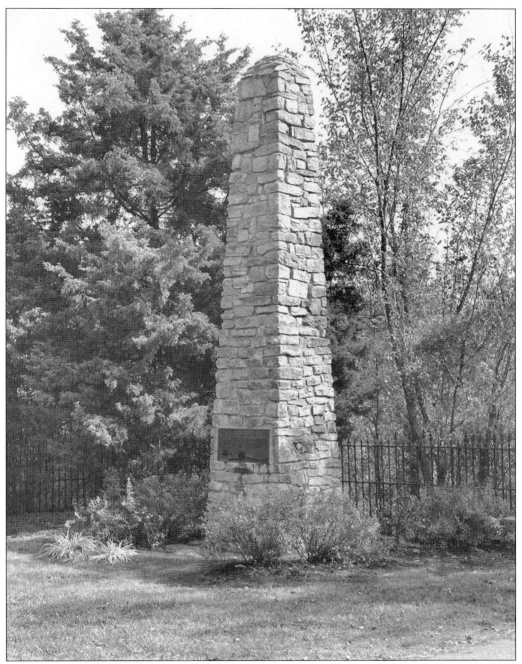

In tribute to Murfreesboro's location at the heart of Tennessee, the members of the Rutherford County Historical Society oversaw the design and installation of an official marker. The obelisk, seen in this 1976 photograph, reflects the 1834 determination that the geographic center of Tennessee was one mile from the campus of MTSU. (Courtesy of the Rutherford County Documentary collection.)

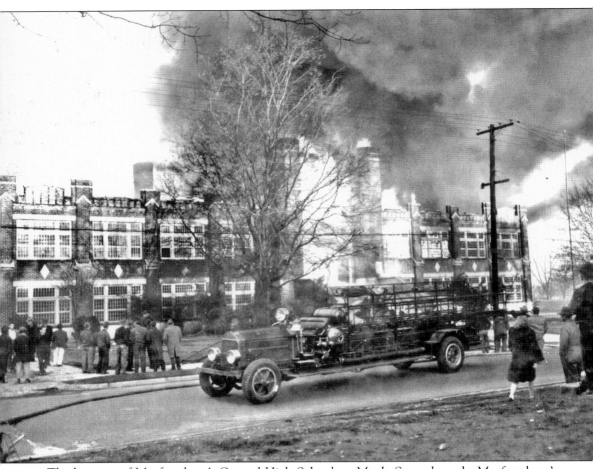

The burning of Murfreesboro's Central High School on Maple Street brought Murfreesboro's locals out en masse. The high school had originally come about as the result of a December 17, 1917, joint session between the county board of education and the City of Murfreesboro, where the resolution was passed to "erect, equip and furnish a building sufficient for a first class high school." It was a terrible loss. (Courtesy of the Rutherford County Documentary collection.)

Seven

PRESIDENT'S LADY, GENERAL'S WIFE

Commenting upon Murfreesboro's Mary Noailles Murfree, known to the world as author Charles Egbert Craddock, Eleanor Gillespie of Murfreesboro wrote: "The town itself was named for her ancestor, and her own life, together with the richness and beauty of her books, has given the town a grandeur and a heritage greater and more enduring that that of the prowess of her Revolutionary ancestor."

This was written in a piece reporting on the dedication of a stained-glass window to the famous local girl's memory. The window was installed at her own St. Paul's Episcopal Church, a church Murfree was instrumental in founding and a church that stands proud today. Gillespie continued, writing, "St. Paul's Church in itself is very lovely, being of pure Gothic architecture with walls of the creamy Sewanee stone from Cumberland Mountains." The church was yet another example of the Murfree family's gift of time and talent to Murfreesboro.

The diverse mosaic of people known in history and connected to Murfreesboro is remarkable for its size. Included among these are local girls made good, such as Sarah Childress Polk who became first lady as the wife of Murfreesboro-educated James K. Polk. The other local girl who entered the world stage was Jean Faircloth MacArthur, the Murfreesboro girl who in her 30s became the wife of World War II's famed military leader, Gen. Douglas MacArthur. Murfreesboro's native sons and daughters also include well-known literary figures Andrew Lytle and woman poet and author Will Allen Dromgoole, who grew up in a two-story log house on Spring Street that later burned.

The images that follow are about the people of Murfreesboro, famous or not so famous, but nevertheless connected forever in some way to the heart of Tennessee.

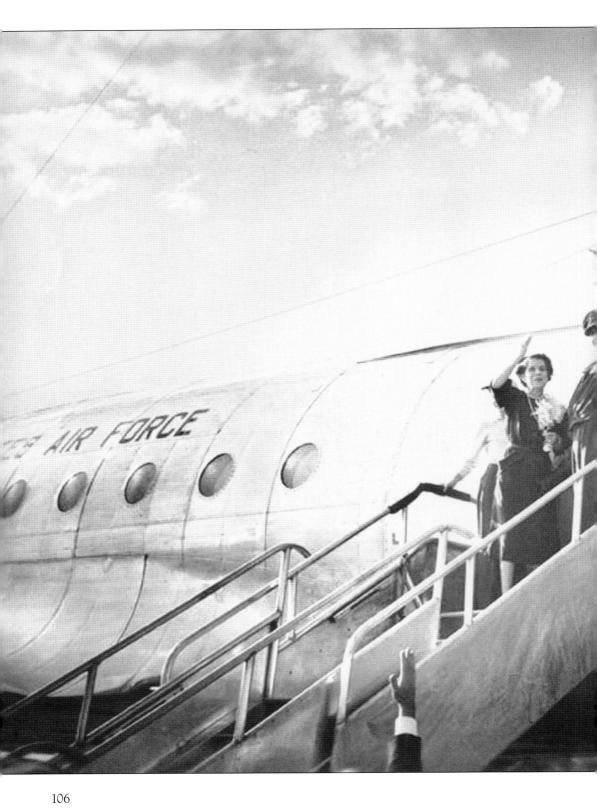

Jean Marie Faircloth MacArthur came home in 1951 with her World War II hero husband, Gen. Douglas MacArthur. Murfreesboro hosted a parade and celebration in their honor. Here the MacArthurs are greeted upon arrival on the tarmac at a Rutherford County airport. Jean Faircloth, as she was known prior to her marriage, was born in Nashville. Subsequent to her mother's divorce from a wealthy banker, Jean moved at age eight to live with her grandparents in Murfreesboro. Her grandfather had been a captain in the Confederate army and arguably influenced her interest in the military life. Jean attended Soule College in Murfreesboro and upon receiving her inheritance from her father's estate, traveled the world. A trip to Manila in 1935 would change her life, as that is where she met the famous general, who was 20 years her senior. (Courtesy of the Linebaugh Library.)

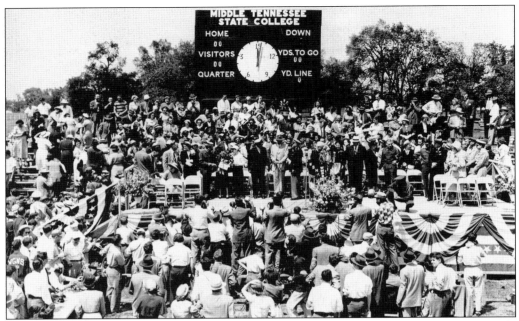

The MacArthurs were taken by motorcade from the airport to Murfreesboro. The motorcade vehicle apparently broke down en route, and a replacement car had to be used. To avoid further delay, the presentation was expedited via on to its planned Middle Tennessee State College campus event. Note General MacArthur is approaching the podium on the right. It was here that Jean Faircloth MacArthur announced to the crowd that Murfreesboro was the only place in the world where she outranked the general. (Courtesy of the Linebaugh Library.)

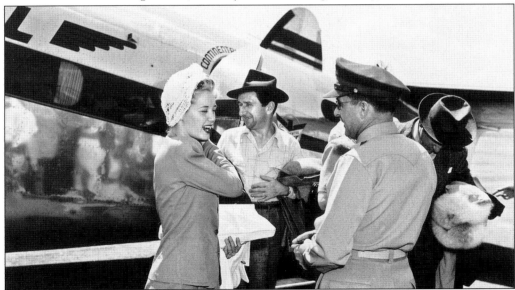

This is another image taken upon General MacArthur and his wife's celebrated arrival at the airport. This photograph shows some of those who also attended this long-planned event. They are visiting on the tarmac at the airport in nearby Smyrna, located in Rutherford County. (Courtesy of the Linebaugh Library.)

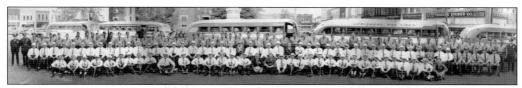

The MacArthur "bond cavalcade" brought participants from Murfreesboro and its environs in support of Gen. Douglas MacArthur. This Lee Lively photograph shows the cavalcade in a signature Lively design, creating a wide arc on the square. (Courtesy of the Lee Lively family and the Southern School of Photography.)

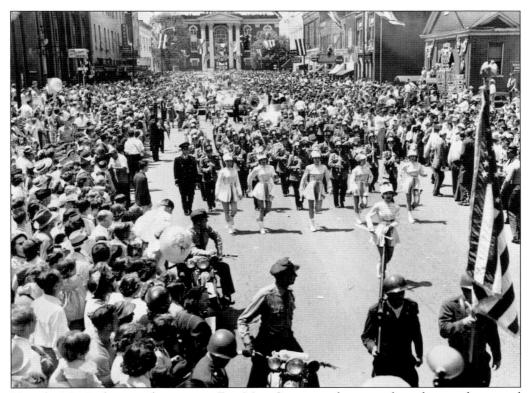

Here the MacArthur parade is seen on East Main Street traveling away from the courthouse and toward its destination at the campus a mile away. Note the man on the sign in the background near Anderson Café. This is near where the present-day City Café is located on East Main Street. The old city hall is also visible to the middle right. City hall was then located at the corner of Main and Spring Streets. (Courtesy of the Lee Lively family and the Southern School of Photography.)

The delightful and always smiling Jean Faircloth MacArthur cuts the homecoming cake presented in her and the general's honor. A local man sits beside her as part of the welcoming reception for the world-famous couple. (Courtesy of the Linebaugh Library.)

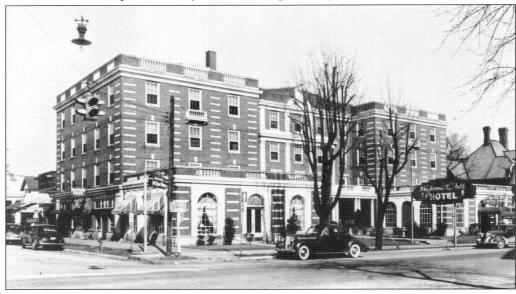

The James K. Polk Hotel was named for another hometown hero. James K. Polk was a student at the Bradley Academy in Murfreesboro. The man to become president married Sarah Childress, also of Murfreesboro and a graduate of the Bradley Academy. This 1929 photograph shows the hotel named in his honor. The hotel was on East Main Street just off of the square. (Courtesy of Bill Jakes.)

The James K. Polk Hotel served as campaign headquarters for the 1960 presidential race. One Richard M. Nixon was the candidate, and he would lose to a fellow named John F. Kennedy. Suntrust Bank now sits in the Polk Hotel's prior location. There have been no large hotels like the Polk near the square since its closing and destruction. (Courtesy of the H. O. Todd family.)

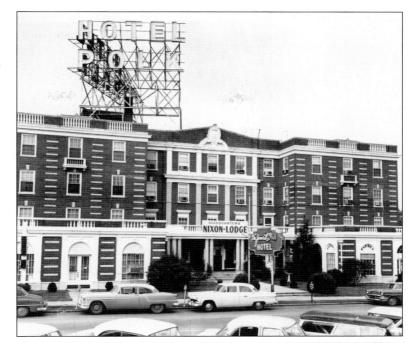

Grantlands was the family home of Mary Noailles Murfree. The grand house stood on the Stones River bluff and was a two-story Southern Colonial of red brick. The descendent of Col. Hardy Murfree, for whom the town was named, Mary became a celebrated writer of fiction under the nom de plume Charles Egbert Craddock. She lived here for 17 of her early years and first began her writing in this place. (Courtesy of the Rutherford County Documentary collection.)

The yearbook at Central High School in Murfreesboro was called *The Craddock*, in honor of its famous citizen Mary Noailles Murfree. *The Craddock* was named of course in tribute to Murfree's pen name, Charles Egbert Craddock. Seen here is the fourth volume of the yearbook ever published. The year was 1926. (Courtesy of the Rutherford County Documentary collection.)

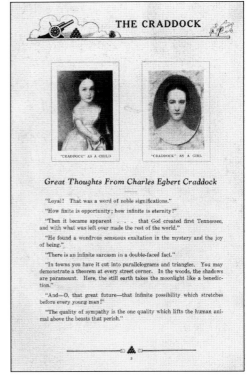

The 1926 Central High School yearbook included some wonderful quotations from the writings of the much-admired Mary Noailles Murfree. Note the third among them: "Then it became apparent . . . that God created first Tennessee, and with what was left over made the rest of the world." (Courtesy of the Rutherford County Documentary collection.)

This dedication page of the 1926 Central High School yearbook shows an image of Mary Noailles Murfree as a mature woman. The dedication mirrors what all of Murfreesboro felt about this literary talent and contributor to her community. Her life and work reflected honor upon her native town of Murfreesboro and her state of Tennessee. (Courtesy of the Rutherford County Documentary collection.)

This monument stands on the courthouse square. Note the bottom inscription stating that in the early years of the Revolutionary War, Gen. Griffith Rutherford commanded all military forces west of the Alleghenies. Rutherford County was named in this Revolutionary War hero's honor. (Courtesy of the Rutherford County Documentary collection.)

This building was constructed in 1901 by the U.S. Department of Treasury on the site of an old livery stable. The building originally served as the post office and later became the Linebaugh Library. After the library relocated, the building was renovated and opened to the public as the center for the arts on December 1, 1995. (Courtesy of Bill Jakes.)

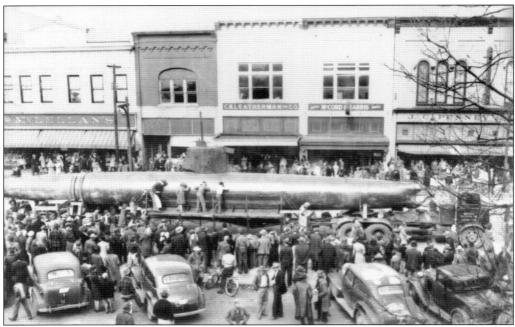

This somewhat perplexing scene is of a bond rally held in downtown Murfreesboro. The presence of Sewart Air Force Base in nearby Smyrna was the catalyst for many a bond rally in Murfreesboro subsequent to World War II. The long cylindrical object being ridden by children is a Japanese submarine captured by the United States in World War II. (Courtesy of Shacklett's Photography/ Southern Heritage Photography.)

This is the home of Capt. William Lytle. Captain Lytle was the donor of the land on which the town of Murfreesboro was founded. Those 60 acres came with a condition: the town has to be called "Murfreesborough" in honor of his friend, Col. Hardee Murfree. The Lytle family cemetery remains at the home's former location, near Memorial and Broad Streets. (Courtesy of Bill Jakes.)

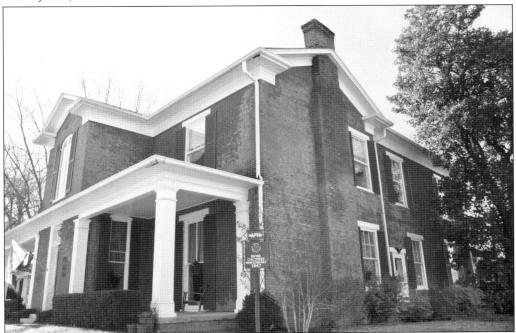

Future first lady Sarah Childress was born in Rutherford County. Her father, Joel Childress, was a planter and a successful businessman. The Childress family home was at Lytle and Academy Streets in Murfreesboro. Sarah attended Bradley Academy, as did her future husband, James K. Polk. The young lawyer was a legislator in the Tennessee General Assembly when Murfreesboro was the state capital. They were married in 1824. (Courtesy of the Wagnon Collection.)

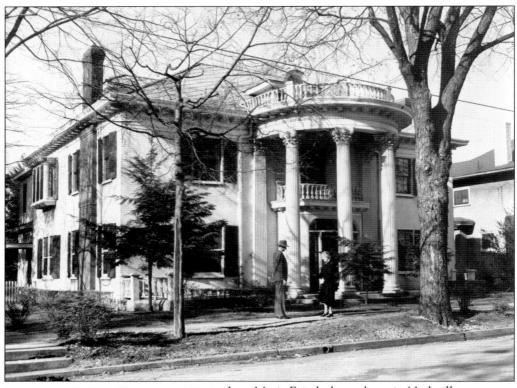

Jean Marie Faircloth was born in Nashville, Tennessee, on December 28, 1898. Her parents divorced when she was very young, and her mother took her children to live in their grandfather's home pictured here on Lytle Street in Murfreesboro. Jean grew up in this house and ultimately attended Soule College in Murfreesboro. This wonderful home was lost to the community. It was used for years as a fraternity house and was ultimately razed. (Courtesy of the H. O. Todd family.)

This is an image of a local celebrity of a different kind. Photographer Lee Lively was a great contributor to the community in his massive output of photographs. He had a signature style that is recognizable a century later. Lively made many photographs of his family, and here he is seen with his lovely wife, Lilly. (Courtesy of the Lee Lively family and the Southern School of Photography.)

This early 20th-century photograph is again photographer Lee Lively with an unidentified woman. (Courtesy of the Lee Lively family and the Southern School of Photography.)

This photograph of Murfreesboro's Lilly Lively shows the photographer's wife as a young woman. (Courtesy of the Lee Lively family and the Southern School of Photography.)

This lovely young local girl is Betty Yeager Lively, as photographed by Lee Lively. (Courtesy of the Lee Lively family and the Southern School of Photography.)

Photographer Lee Lively is seen here with Dr. Cason, for whom the present Cason Lane thoroughfare is named. Lively and the doctor take on their roles as gentlemen duck hunters. (Courtesy of the Lee Lively family and the Southern School of Photography.)

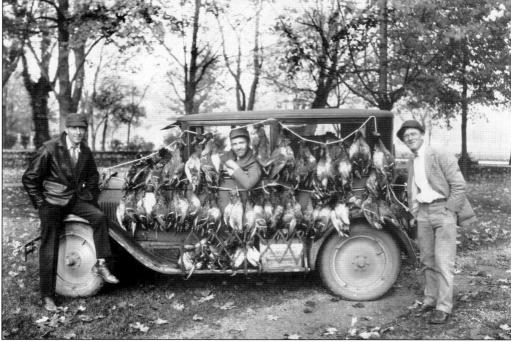

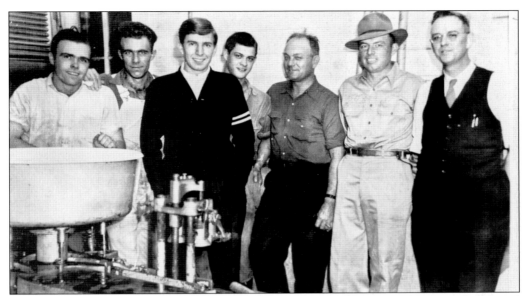

In 1923, the Murfreesboro handbook reported that the second largest creamery in the United States was located in Murfreesboro. That creamery was the Rutherford County Creamery. Dairy farming was major for Middle Tennessee in the early to mid-20th century. Seen here are the milkmen that delivered for Carnation. The old Carnation plant smokestack is still visible from Old Fort Parkway near downtown Murfreesboro. (Courtesy of the Rutherford County Documentary collection.)

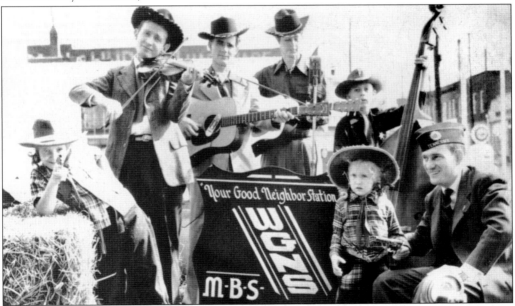

WGNS Radio is Murfreesboro's hometown station and is found at 1450 AM. Its call letters standing for "Good Neighbor Station," this Murfreesboro landmark is located just south of the square on Church Street. WGNS has been broadcasting news, weather, and entertainment to Murfreesboro since December 31, 1946. Seen here is WGNS and Murfreesboro businessman Cecil Elrod in the midst of a musical event being broadcast live. (Courtesy of WGNS.)

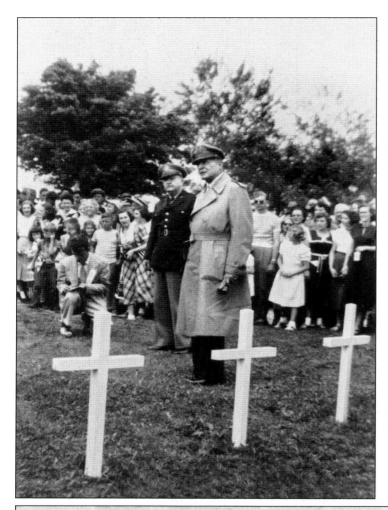

Here Gen. Douglas MacArthur tours a military cemetery during the Murfreesboro and Rutherford County celebration in his honor. This cemetery is believed to be near Smyrna airport, where he and Jean MacArthur arrived. Douglas MacArthur was at that time one of the best-known names in the world. His fans in the background are crowding as close as they can. (Courtesy of the Linebaugh Library.)

This is the image of the actual bond documents used by the cavalcade. It references Jean Faircloth MacArthur, Gen. Douglas MacArthur, and their son Arthur. It incorporates the general's infamous Battle of Bataan and the need to support the war by buying U.S. bonds. The likely method of operation for the cavalcade was to tour the region and sell bonds in conjunction with promoting the general's upcoming visit. (Courtesy of Jim Laughlin.)

This was a poster created by Cecil Elrod's French Shoppe in tribute to General MacArthur's upcoming visit to Murfreesboro. The first paragraph includes the following: "It was civilization's great good fortune that he was on his job that peaceful December Sunday—ready when the yellow wave washed across the blue Pacific." (Courtesy of the Elrod family.)

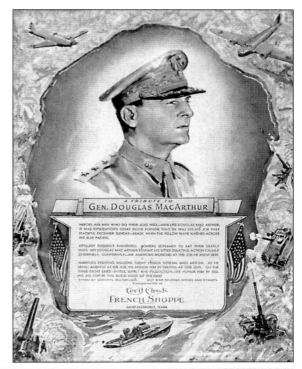

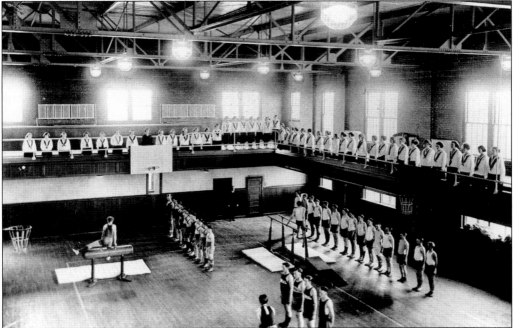

Early-1900s college students in a gym class are depicted here. These young men and women were not just training their minds to be school teachers at the Middle Tennessee Normal School, but they were also training their bodies. (Courtesy of the Albert Gore Research Center, Middle Tennessee State University)

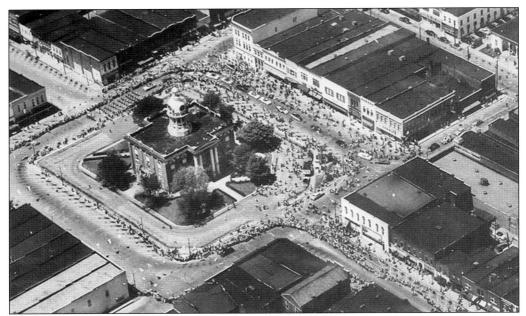

This photograph captures one of the largest crowds of Middle Tennesseans in the history of Murfreesboro's square. This aerial view, taken that exciting day in 1951, shows the parade in MacArthur's honor. The MacArthurs slowly made their way down East Main Street toward the campus, where they each made speeches to the rapt crowd of admirers and supporters. (Courtesy of Shacklett's Photography/ Southern Heritage Photography.)

This is a rare smile from the general in an exchange with the love of his life, Jeanne Faircloth MacArthur, on stage at the Middle Tennessee State College event. No photograph among those generated from that day shows the general without his military hat firmly in position. (Courtesy of the Linebaugh Library.)

This lovely little white chapel is one of the premier attractions at Cannonsburgh Village in Murfreesboro. Named Williamson Chapel, it seats 75 people and has stained-glass windows, an antique pump organ, and a lighted candelabrum; its short aisle is a romantic walk into history. Many local citizens elect to get married at this chapel. This, along with the many events held at Cannonsburgh, make it an important gathering place for Murfreesboro. Uncle Dave Macon Days is one of a few old-time music competitions in the United States, and the annual festival is a major summertime event for the region. It was named for Uncle Dave Macon, an early Grand Old Opry superstar who lived near Murfreesboro. (Courtesy of the Rutherford County Documentary collection.)

In an effort to relocate the county seat of Rutherford County to a more centralized location, Capt. James Lytle donated 60 acres of Lytle's choicest land. The new site was to be named Cannonsburgh after Newton Cannon, one of the first Whig governors of Tennessee. Lytle requested that a courthouse be built and that the name of the village be changed to Murfreesborough in honor of his friend Col. Hardy Murfree, with whom he served during the Revolutionary War. It is said that the original village bore the name Cannonsburgh for a period of about six weeks. Cannonsburgh was organized and dedicated in 1976 as a living museum depicting American village life from the pioneer era to the machine era. (Courtesy of the Rutherford County Documentary collection.)

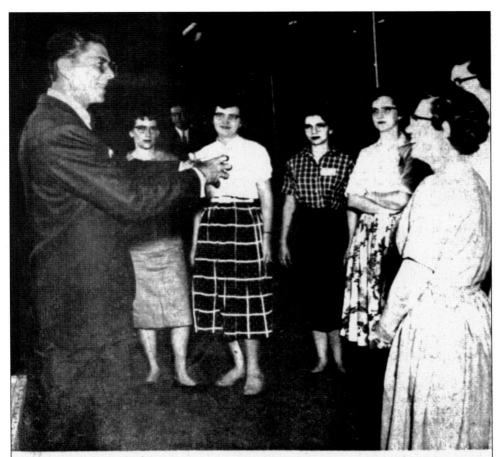

'PROGRESS IS OUR MOST IMPORTANT PRODUCT' — Ronald Reagan, replete with aviator glasses, talks to a group of Murfreesboro General Electric plant employees during a visit to the plant in 1959.
—Photo courtesy of G.E.

Reagan made city visit during G.E. years

Once the home to Tennessee Red Cedar Woodenware, Sunshine Hosiery Mills, Putnam Overall Manufacturing Factory, and the Rutherford County Creamery, industry changed with the arrival at Murfreesboro of new industry giants, including General Electric. The future governor of California and president of the United States, Ronald Reagan, was then spokesman for General Electric, hosting its regular television program "GE Theater." In this 1959 photograph, Reagan is on one of his ongoing "ambassador of goodwill" tours, visiting with employees at GE plants across the country. Here Reagan visits with Murfreesboro employees at the plant located on Northwest Broad Street. President Reagan later credited the tours meeting American workers on behalf of General Electric as one of his greatest learning experiences and as a major element in his subsequent political success. (Courtesy of the Rutherford County Documentary collection.)

WESTERN UNION
TELEGRAM
W. P. MARSHALL, PRESIDENT

The filing time shown in the date line on domestic telegrams is STANDARD TIME at point of origin. Time of receipt is STANDARD TIME at point of destination

1962 JUL 14 PM 12 42

CTB024 NP228

YHB015 GOVT PD YH SUMMER WHITE HOUSE HYANNISPORT MASS JUL

MRS CECIL ELROD JR CHAIRMAN CENTENNIAL BALL 216P ED

 CIVIL WAR CENTENNIAL COMMEMORATION MURFREESBORO TENN

IT GIVES ME GREAT PLEASURE TO SEND GREETINGS TO YOU

ATTENDING THE CIVIL WAR CENTENNIAL COMMEMORATION AT

MURFREESBORO. TENNESSEE PLAYED A VITAL ROLE IN THE CIVIL WA

ITS MEN SHOWED GREAT COURAGE--FIGHTING FOR THE BLUE AND

FIGHTING FOR THE GREY. TENNESSEE REPRESENTS THE UNITY AND

THE STRENGTH WHICH EMERGED AFTER THE BATTLES WERE FINISHED.

WITH ALL BEST WISHES :

 =JOHN F KENNEDY

On July 14, 1962, Murfreesboro's Betty Elrod received this exciting telegram from then-president John F. Kennedy. Elrod served as the chairman of the Civil War Centennial Ball held in Murfreesboro as a part of the Civil War Centennial Commemoration. This greeting from the Kennedy compound at Hyannisport, Massachusetts, was the bookend to a 100-year journey for Murfreesboro. Its beginning was in 1862, the year in which Murfreesboro would be Union, then Confederate, then Union again due to Nathan Bedford Forrest's July 13 raid upon federal forces encamped at Oaklands and subsequently because of the horrific and bloody Battle of Stones River, which commenced on the last day of that year, December 31, 1862. Note President Kennedy's commentary 100 years later that "Tennessee represents the unity and the strength which emerged after the battles were finished." (Courtesy of the Elrod family.)

BIBLIOGRAPHY

Gillespie, Eleanor Molloy. *Memorial Window To Mary Noailles Murfree: Murfree Family Papers.* Southern Historical Collection, University of North Carolina at Chapel Hill, 1980.

Handbook of Murfreesboro and Rutherford County. Murfreesboro, TN: The Mutual Realty and Loan Company and Home Journal, 1923.

Hankins, Caneta Skelley and Carroll Van West. *Hearthstones: The Story of Rutherford County Homes.* Murfreesboro, TN: Oaklands Association, Inc. and Center for Historic Preservation at Middle Tennessee State University, 1993.

Hughes, Mary B. *Hearthstones.* Murfreesboro, TN: Mid-South Publishing Company Inc., 1942.

Johns, Thomas N. Sr. *The Nashville and Chattanooga Railroad Through Rutherford County 1845–1872.* Murfreesboro, TN: Rutherford County Historical Society, Publication No. 5, 1975.

Maslowski, Peter. *Treason Must Be Made Odious: Military Occupation and Wartime Reconstruction Nashville Tennessee 1862–1865.* Ann Arbor, MI: University Microfilms, 1973.

Nelson, Sheila. *America Divided: The Civil War 1980–1865.* Philadelphia: Mason Crest Publishers, 2005.

Phelan, James. *School History of Tennessee.* Philadelphia: E. H. Butler and Company, 1889.

Rood, Elma and Gertrude Lingham. *Taking Care of the Family's Health: A Teaching Guide for Rural Classes.* Madison College, TN: The Rural Press, 1938.

Wray, Henry. *Soujourn In Murfreesboro.* Murfreesboro, TN: Rutherford County Historical Society, Publication No. 1, 1973.

Across America, People are Discovering Something Wonderful. Their Heritage.

Arcadia Publishing is the leading local history publisher in the United States. With more than 3,000 titles in print and hundreds of new titles released every year, Arcadia has extensive specialized experience chronicling the history of communities and celebrating America's hidden stories, bringing to life the people, places, and events from the past. To discover the history of other communities across the nation, please visit:

www.arcadiapublishing.com

Customized search tools allow you to find regional history books about the town where you grew up, the cities where your friends and family live, the town where your parents met, or even that retirement spot you've been dreaming about.